MONSTERS

Copyright © 2017 by Derrick Jensen

Illustrations copyright © 2017 by Anthony Chun, Cherise Clarke, Kyle Danley, Sandra Griffin, Riina Kellasaare, Stephanie McMillan, Geoffrey Smith, Anita Zotkina

This edition © PM Press 2017

A FLASHPOINT PRESS FIRST EDITION

Cover and interior design by Tiiu Kellasaare
Edited by Theresa Noll and Mary Holden

Flashpoint Press, PO Box 903, Crescent City, CA 95531, www.flashpointpress.com
PM Press, PO Box 23912, Oakland, CA 94623, www.pmpress.org

10 9 8 7 6 5 4 3 2 1

ISBN (paperback) 9781629634364
Library of Congress Control Number: 2017939521
Library of Congress Cataloging-in-Publication Data
Names: Jensen, Derrick, 1960- author.
Title: Monsters / by Derrick Jensen.
Description: First edition. | Crescent City, CA : Flashpoint Press, 2017.

ALSO BY DERRICK JENSEN

WITHDRAWN

Listening to the Land: Conversations About Nature, Culture, and Eros

Railroads and Clearcuts: Legacy of Congress's 1864 Northern Pacific Railroad Land Grant

A Language Older Than Words

Standup Tragedy, 2 CD set

The Culture of Make Believe

Strangely Like War: The Global Assault on Forests

Walking on Water: Reading, Writing, and Revolution

The Other Side of Darkness, 3 CD set

Welcome to the Machine: Science, Surveillance, and the Culture of Control

Endgame, Volume 1: The Problem of Civilization

Endgame, Volume 2: Resistance

Thought to Exist in the Wild: Awakening from the Nightmare of Zoos

As the World Burns: 50 Simple Things You Can Do to Stay in Denial

Now This War Has Two Sides, live double CD

How Shall I Live My Life?: On Liberating the World from Civilization

What We Leave Behind

Songs of the Dead

Lives Less Valuable

Resistance Against Empire

Mischief in the Forest

Deep Green Resistance

Dreams

Truths Among Us: Conversations on Building a New Culture

The Derrick Jensen Reader: Writings on Environmental Revolution

The Knitting Circle Rapist Annihilation Squad

Earth at Risk: Building a Resistance Movement to Save the Planet

The Myth of Human Supremacy

MONSTERS
Short Stories

Written by

DERRICK JENSEN

Illustrated by

ANTHONY CHUN

CHERISE CLARKE

KYLE DANLEY

SANDRA GRIFFIN

RIINA KELLASAARE

ROXANNE MANN

STEPHANIE MCMILLAN

GEOFFREY SMITH

ANITA ZOTKINA

CONTENTS

Monster illustration by Roxanne Jane Mann
Endpiece illustration by Cherise Clark

Can I describe how I feel within the context of our culture? . . . perhaps like a hurricane tethered to a bullet train, sometimes . . . as though the part of my brain that processes time is broken, sometimes . . . maybe other parts too . . . as if I'm a clown & a caricature rather than real . . . as if while finding beauty in the complexity I've become caught in the gears . . . as if I'm alone even when I'm not . . . sometimes . . .

Riina Kellasaare

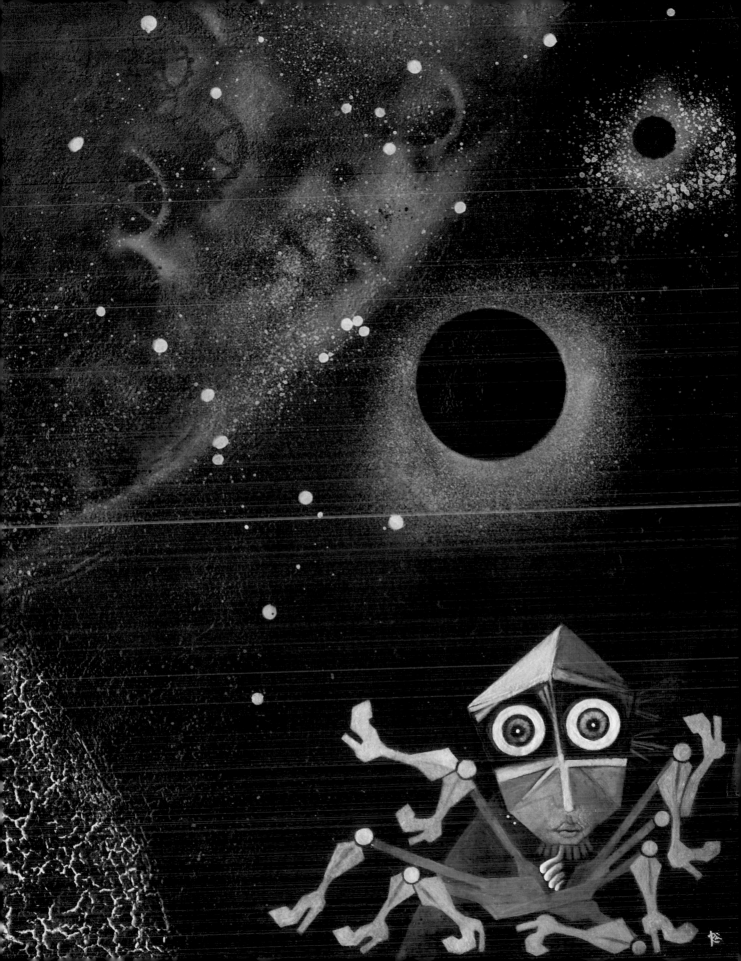

INTRODUCTION

From beginning to end, this book, like many books, is the result of a series of conversations.

The first conversation took place at a local book signing. Someone approached me, handed me a pile of her books tied with a ribbon, and said she was an artist who'd like to work with me. I often get approached by people who want to collaborate, and I have to turn almost all of them down, mainly because I'd never get any of my own work done. But there weren't many people at the signing, and the more I looked at her artwork, the more I liked it. And I was between projects, so. . . .

A couple of lunches later we'd decided I'd write a series of stories on monsters, and she'd illustrate them. I was excited. When I was a child I loved reading myths and fairy tales. In my early twenties I graduated to reading Joseph Campbell (whose book *The Hero with a Thousand Faces* had as its working title *How to Read a Fairy Tale*) and others who described the importance of stories to the transmission of culture from generation to generation. The stories of Hercules, then—or Hansel and Gretel, for that matter (and of course the same is true for every cultural story, from *Star Wars* to *'Salem's Lot*)—can be read as lessons on how to be human. Then in my late twenties I encountered the work of feminists like Mary Daly and Jane Caputi, who made clear that these stories not only teach us how to be human, but teach us how to be human within the particular cultural context of the story's tellers and listeners. So Jason slaying Medusa or the male god Marduk slaying the female dragon and earth-creator Tiamat became stories of the violent ascendancy of patriarchy. The same can be said of stories in the Bible, and the same can be said of many of the stories in this culture, from those told by Hitchcock to those told by Norman Mailer. And these stories, even those told a very long time ago, have real-world effects.

All of which brings us back to stories about monsters. What do they teach us? Why do we so love them?

Whatever the answers, stories about monsters are among the most popular ever told, from our first oral tales to Bram Stoker's *Dracula* to the latest Stephen King novel.

Perhaps you can see why I was excited about this project. I wanted to write stories that would reimagine monsters. And no, I didn't want to make them warm and fuzzy. I wanted them (or at least some of them) to still be frightening. Monsters do exist, and they scare the hell out of me.

But the older I get, the less frightened I am of Medusa, and the more frightened I am of her killer Jason.

So I wrote the stories. Then I handed them over to the artist, and. . . . Well, nothing. She disappeared. Which reminded me of one of the reasons I don't generally collaborate with people I don't know.

It all turned out for the best, however, because this gave me the opportunity to widen the conversation, to include not just one artist but many, each adding his or her own vision to these stories. That process has been a joy, and from my perspective at least, a triumph. I'm proud of the varied interpretations these artists have brought to these stories.

And finally, I've always loved learning about the seeds from which other authors' stories germinate, so at the end of the book I've appended a brief description of each story's inspiration.

Enough of this palaver. The bottom line is that I enjoyed writing these stories, and I hope you enjoy reading them. I must admit I also hope that at least one or two frightens you just the tinlest bit.

Monsters

ILLUSTRATIONS BY ANITA ZOTKINA

HE WAKES, AS HE SO OFTEN DOES, moments before his alarm is to ring. He reaches to the nightstand to turn it off. He hears the soft sound of his wife's footfalls as she makes her way across the still-dark room, hears the door open, then sees her silhouette against the slightly-less-dark hall. The door shuts again. She's on her way to wake the children, and then to the kitchen to make breakfast for all.

He is filled, as he so often is, with a profound gratitude for this life he has been given, for the family he shares, for the simple elegance of their daily routines, for his ability to work and to provide food and shelter for them, especially during this time of sacrifice.

He reaches again to the nightstand, this time to turn on the light. Then he sits, and slides his feet from under the covers and over the side of the bed. He stands, walks to the wardrobe, opens it. He dresses.

By now he can hear the children, their sleepy voices drifting through the walls.

◑◐

He's at the kitchen table. The scents of coffee, sausage, and eggs permeate the air. The children file in, sit in their accustomed chairs. His youngest son's shirt is buttoned wrong, so he points this out. The child fixes the error with his tiny hands.

An overweight, graying dachshund waddles into the room. The man looks at his children, ostentatiously checks to make sure his wife's back is turned, winks, then hands the dog a piece of sausage.

His wife says, "I know what you just did."

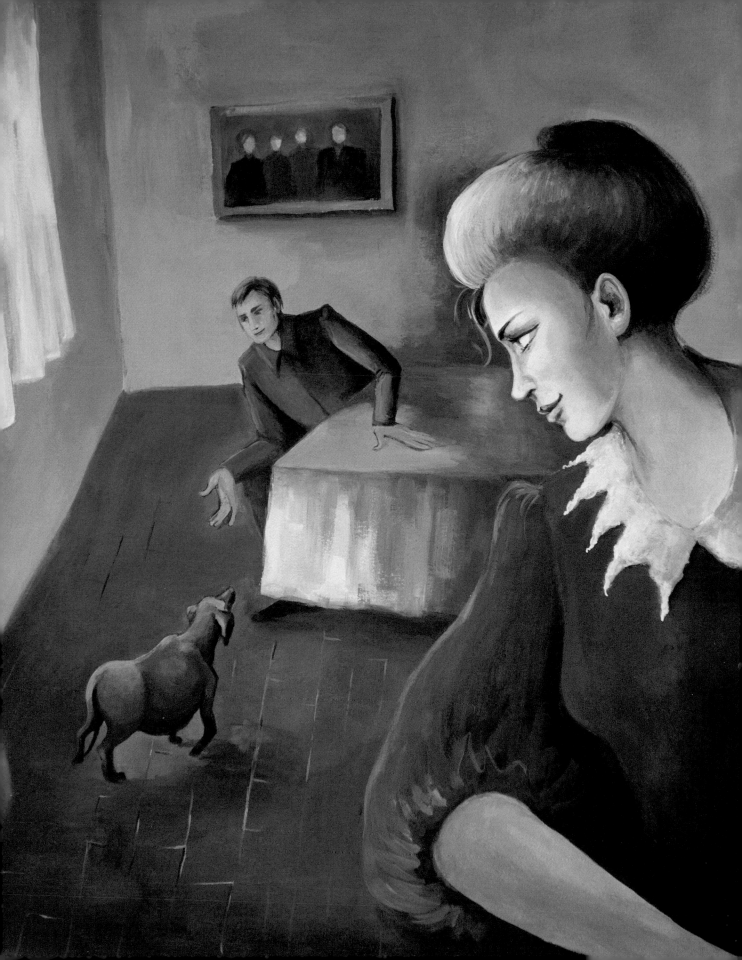

The children giggle.

She turns to face him, says, "We shouldn't be wasteful. We must be grateful for what we have."

"I am," he responds, and he thinks again about his good fortune to be able to provide all this for his family. He asks his children, "Are you grateful?"

"Yes, papa," they say.

He takes a bite of eggs, chews carefully, swallows. He looks at the dog again, then asks, "Where's Schatzi?" Normally their two elderly dachshunds are inseparable.

His wife responds, "She can't get up this morning." A look passes between them. She continues, "I think it may be time."

Another look between them. His expression warns her not to discuss it in front of the children.

Message received, she says, brightly, "But maybe some sausage will convince her to get up." She looks at the children, "Who would like to give Schatzi a treat?"

All of the children raise their hands.

∞

He makes the short walk to work. The sun is not yet up. There was a wind in the night, so the air is clean. One of the few things he does not like about his work is that sometimes the smell offends him. But not on mornings like this.

∞

The transition from home to work doesn't come for him the moment he steps out of the door of his home, a villa provided on site. Nor does it come the moment he walks into his administration building. It does not come as he greets those who work for him. Nor does it come when he exchanges pleasantries with his personal secretary. It does not come even when he walks into his office.

It comes as he sits in his chair. That is the moment each day when the awesome responsibility he carries strikes him anew, the responsibility he carries as commander of Auschwitz-Birkenau.

∞

This is what happens.

You don't panic when the first entrance is sealed. There's no reason to panic: that's why there are multiple exits. You move to the next exit. It also is sealed. You're still not concerned. Of all places, this is where you're supposed to be safe. Nonetheless it is troubling that two entrances

are sealed. You check out a third, and a fourth. All sealed.

You're not the only one to notice. Many of the younger members of your community are confused, discomfited. You and some of the others of older generations reassure them, the same way members of older generations among your kind have always reassured those younger when they're scared. You say again and again, "It's going to be okay."

They start to calm. Then one of your daughters—she's nothing more than a pup, really—complains of nausea. Her grandmother—your mother—rushes to her side, strokes her head and back, talking to her constantly. Then one of your nephews doubles over, begins moaning from abdominal cramping. Your sister hurries to him. The nephew lets go with explosive diarrhea. This does not deter her from comforting him.

You find the father of your children. He opens his mouth as if to speak, and blood gushes out. You touch his hair, whispering to him. Blood pours from his nose, from his other orifices. He cramps, then begins to convulse. He tries to speak. You say to him softly, "Don't talk. You're going to be okay. You're going to be okay."

You're having a hard time holding down your own panic. Around you, your friends and family are losing control of their bodies. They are vomiting, defecating, bleeding all over themselves. Some are moaning or keening. A few are screaming. You want to attend to them, but you need to help your beloved.

And then his body stiffens, seizes, seizes, and seizes again. Something shifts inside of him. Then it leaves, and he is finished.

You turn away from him and toward the chaos that until very recently was your community. You bark out commands, telling this one to take care of the young, that one to find a way out. You don't know what is sickening and killing everyone. You just know there must be a relationship between the forced sealing of the entrances and the deaths that have now followed.

Those around you are vomiting, convulsing, seizing. Those who can still control their limbs are clawing at the walls. You move from individual to individual, trying to calm those you can, comfort those you can't. You keep saying to anyone who will listen, "It's going to be okay. We will get out of here."

And then you feel it. Your mouth begins to water, and the first wave of nausea rolls through you. You force it down, but it returns. Your chest tightens, and in that moment you know—as you've known all along, but would not allow yourself to say, even to yourself—how this will end. You begin to vomit blood, and you desperately wish that there was someone here to touch and kiss and stroke you, someone to whisper to you over and over, "It's going to be okay."

She knocks on his office door, hears him say, "Enter." She does. She's about to speak when his phone rings. He has set his ringtone to play "Tears of a Clown."

She likes the song, but hates that he's using it. She hates most everything about him, from his intentionally ugly hipster glasses to his expensive suits to the smug superiority he seems to show at every moment.

Last week his ring tone was the opening vocals of "Afternoon Delight." She knows he chose it to convey the message to anyone within hearing range that he can choose a crap song and still be cool. He pretends he doesn't care what other people think, but he's so empty that his entire persona Is based on his perception of how other people perceive him.

So far as she can tell, he doesn't have a genuine character, or anything resembling an interior life, but only a shell he puts forward to everyone he sees. His only redeeming quality, she thinks, is his ability to make money. But, she also thinks, the ability to make money makes up for more or less every sin. She thinks it's interesting, too, that making money is the only area of his life where he actually doesn't care what other people think. He's going to make it, and if someone doesn't like it, well, they can fuck right off.

He glances at his phone to see the number, gives the screen a tap, then puts it to his ear. He says, "Speak."

Fucking typical, she thinks.

A silence as the caller say something, then she hears her hipster boss, the moneymaker, say, "You killed them? Good."

More silence.

"All of them?"

Short silence.

"Why not?"

Long silence.

"Don't give me that shit. You were hired to kill them all. We need them all dead."

Silence.

"I don't understand why anyone cares either. They're vermin. They're in the way. They have to die. It's not like they're humans, and Jesus, even if they were . . . But they're not. Kill the rest of them."

Silence.

"I don't want excuses. I don't hire you to tell me what to do, and I don't hire you to tell me what's possible. I don't hire you to tell me what's legal. I hire you to figure out how the fuck to do what I tell you."

She's only half listening. She'd be hard pressed to say how many times she's had this same experience, standing in front of this same desk, listening to him speak on his phone, telling whomever is on the other end that he will brook no impediment to making money.

He ends the call without a good-bye and palms it down hard on his desk. He looks at her, says, "Prairie dogs. Fucking prairie dogs. Holding up a multimillion dollar mall. Can you fucking believe it?"

She asks, "How do they kill them?"

Moneymaker makes a sprinkling motion, says, "Drop in poison pellets, seal up the dens." Then he does a double-take before saying, "The fuck you care? They're in the way."

⟁⟁

This is the moment you live for. Not this one, right now, but the one you know is coming soon. You know it's coming soon because it's that time. You know it's that time because everyone else does, too. You can tell by all the jostling: everyone's trying to get in position.

"Hey," you say to one of the jostlers. "Quit poking me." You poke her back. She pokes you back. You poke her back. This could go on for a long while, especially when—as is nearly always the case—the light has given one or both of you headaches. But this time it dies down after a few pokes.

You are perfectly aware that things could be worse: you could be stuck in a different part of the room, where you couldn't see the moment you live for. Then things would be really bad.

You look across the room and stare intently at the door in the otherwise featureless wall. You see that many of the others are doing the same. You know this is the moment they live for, too. You know this because all of you have talked about it endlessly.

⟁⟁

Your best friend died last week. She was also sometimes your worst enemy, but that was to be expected, all things considered. Sometimes she just had to poke you, and then you'd poke her back. Sometimes when your or her head hurt from the lights this could go on through almost an entire light cycle. Sometimes you were both almost bald from all the poking.

She loved to talk. She especially loved to talk about the moment you all live for, about how she knew what it was like beyond the door. She told everyone about it, whether or not they listened.

Often you didn't believe her, not only because so many of the stories she told seemed frankly impossible, but also because she was, if you're honest with yourself, completely insane.

Not that you can blame her for that, either. Who wouldn't go a little crazy?

○○

After she died, her body remained for several light cycles before any of the Others took her away. You tried to tell the Others she was dead, but they didn't listen to you. They never do. Some of your friends—you guess you'd call them friends, though you're not sure you like them all—think the Others never listen because they're deaf. But you're pretty sure they can hear. You just don't know if they're capable of intelligent response to anyone but themselves. There is some debate among your friends as to whether they're intelligent at all. You think they are. You think they just don't care.

○○

This is the moment you live for. The door opens, and one of the Others enters. Once inside, the Other closes the door.

That's it.

The moment has nothing to do with the Other, except that he is the instrument that brings the moment you live for: the far-too-brief vision of what lies beyond the door.

You see what your best friend called dirt, and beyond that what your best friend called grass, and beyond that what your best friend called a tree, and above that what your best friend called sky. You burn these into your memory so you can see them again and again through the hellish monotony—broken only by pokes and more pokes by those who are too close to you—that is the interminable light cycle.

○○

Here is what your best friend said to you. She said that she herself once lived beyond the door. Not here, beyond this door, but somewhere else entirely. She was always vague as to where and how this happened, which is one reason you never believed her. And why would she have traded "dirt" and "sun" for this?

Once, your best friend told you that she had never actually been outside herself, but had heard stories about what lay outside passed down generation to generation, mother to daughter. That didn't make any sense either: what's a generation, and what's a mother?

There's no such thing as a mother. You've never heard such nonsense. You suspect that either

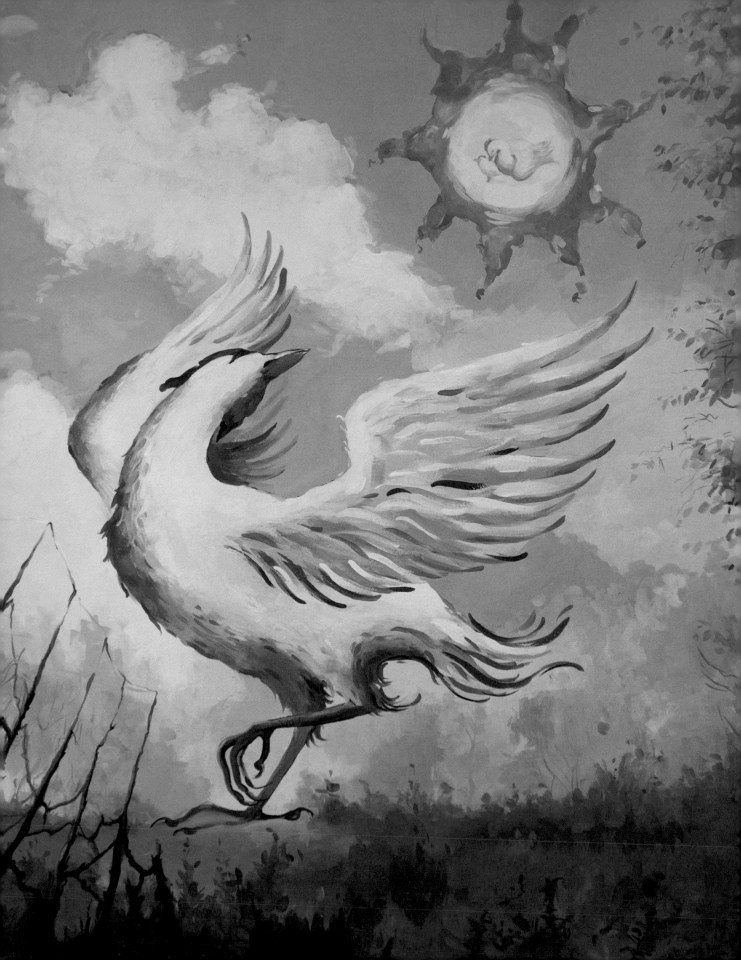

she was nuts—and once again who could blame her—or that she had a great imagination, or that she had heard these stories from a hen who heard them from a hen who heard them from a hen who . . .

As such the stories had become mythic. And most importantly they passed the time, so you listened. She said that beyond the door you can walk as far away as you would like from everyone else, and she said that you can stretch your wings all the way from tip to tip. You told her you didn't believe her, and that you didn't believe that was possible. Your muscles won't even go that far, you said.

She also said she took baths in dirt, and threw it all over herself. You asked her what dirt is. She said she loved to eat grass, and you asked her about grass, too. She said you could roost in trees. You asked her to explain the word roost as well as the word trees. She loved the wind, she said.

You just stared at her, unblinking.

She said her favorite thing in the world was the sun, that it was bright and warm and yellow and it moved across the sky. Whenever she'd say that you'd always tell her that was too much, and then you'd poke her, but not real hard, so she'd know you didn't mean it.

Then she'd say that no, her favorite thing in the world wasn't the sun, but her mother. "What's that word?" you'd say.

She'd say that when you were a baby your "mother" would talk to you and teach you things. And when you were scared she'd put you under her wing and hide you with her body.

When she'd say this you'd always tell her that you didn't want to hear such nonsense, but she always knew that really you did. And she said there were roosters, whatever they were, who could be a pain and who were always prancing around and trying to impress everyone, but whom she was also occasionally glad to know.

She also said that sometimes the roosters were noisy, especially just before the "sun came up," whatever that means, and that the roosters always claimed it was their singing that caused the sun to rise. She said she never believed that at the time, but since she's been here she hasn't seen a rooster, and she hasn't seen the sun, so maybe they were right.

You didn't respond to that at all, because even more than the other crazy stories, you couldn't imagine what this story described.

But it's a nice dream, isn't it? The story helps you survive another light cycle, and that's really all that matters.

◖◗

The lights are off, and the room is as quiet as it ever gets. Most of the hens are sleeping. Hen 10 in cage A-4-38 (Sector A, Row 4, Cage 38) is asleep. She's dreaming of something her friend had called the sun. In the dark warehouse, her skin twitches slightly as she dreams she feels wind on her body. In this dream she stretches her wings as far as they will stretch, and she dances in the dry dirt. She dreams of a mother who covers her with her wings and protects her from all bad things. But even as she sleeps, a part of her knows she is dreaming, and that part of her hopes that this sleep lasts forever, that she never again wakes up.

ɔɔ

The newscaster reads from her teleprompter: "Egg farmers are fighting for their lives as the public considers a referendum to ban the safe, humane, and essential caging of egg-laying hens. This referendum is not only an assault on farmers but on poor Americans, who will no longer have access to this inexpensive and nutritious part of their diet. Further, because poor Americans often receive federal assistance, all taxpayers will be 'shelling out' money on this boondoggle of a bill . . ."

ɔɔ

You're tired. Really tired. You can't wait to get home. You know that's a cliché, but right now you're too tired to think in much other than clichés. You hurt all over. You're hungry. You want to sleep. You've been through so much. The only thing keeping you going is that you don't have much farther to go now.

And you're lonely. You've heard stories that there used to be thousands of you, and then hundreds, and even a few years ago you remember there were a couple of dozen. Last year there were five. This year three started the trip, and now there's only you.

The trip has been full of disappointments. It seems every trip your entire life has been full of disappointments. Things changing in ways you don't like. That's one reason you're so tired and hungry. You've heard stories that generations ago the trips used to be fun, an annual adventure, a sort of vacation. Travel a little, stop and rest and play around, sample the local foods, and then after you've slept off your full belly, get the travel bug again and head on up the coast. That's not to say it wasn't tiring, even back then. But everyone knows that traveling is always tiring, even when it's fun.

And the parties along the way! Seeing old friends you haven't seen since, well, sometimes it seems like forever even though it was only last year. And catching up on the gossip! Oh, the gossip! She did what? That little rascal. I can't believe it. And who else did what with whom? And

look at how your children have grown! I remember when they were only this big. Chatter chatter chatter. Even more memorable than the chatter were the songs. Between the lovers of the day and the night owls, someone or another was always singing as though their heart would burst.

These are stories you've been told about how it used to be. In your lifetime the get-togethers have never been so joyous. Rather they're occasion for an accounting of the dead.

You hate to admit it, but you resent those who came before. How did they have it so good? It's unfair that you never got to experience any of those days. Sure, you've had your share of gossip. And it's still been nice to see old friends. But the ache for those who've gone never goes away.

<p style="text-align:center">◑◑</p>

The first sound you heard in your life, long before you broke through your egg, long before you felt the sun or the wind or anything else, long before you knew there was color, long before you knew there was anything in the world but a long ceaseless dreaming, was the sound of singing. It was the most beautiful thing you could imagine. That sound, the soft inviting sound of your mother's voice, gave you all the courage it took when it came time to break the shell and find out that the world was larger than your curled up body.

<p style="text-align:center">◑◑</p>

You think often of the last thing your mother said to you before your first migration, something that her mother said to her, and her mother to her, for as long as your family can remember, which was that the journey of a hundred days begins with a single beat of your wings. With that she leapt into the air and was off. Of course you joined her, as did the rest of your family.

What she didn't emphasize—and this was undoubtedly wise on her part, or you might have been too scared to take that first beat on the long journey—is that after the first wing beat there is another, and then another, and then another, until there are too many to count, and that there are times when the only thing you know is fatigue.

There are, you have learned, many flavors of fatigue. There is the delicious fatigue at the end of a long day, when your muscles and bones and brain and heart seep into sleep the moment your feet find a branch. And there is the dry and deadened taste of fatigue at the end of the whole hundred day journey, when every part of you aches and the only things that keep you going are the knowledge that you can do one more wing beat, and then one more, and then one more, but you don't know after that; and the knowledge that soon you will be sitting on the branch you love so much in the tree you love so much in the place you love so much, the place you first felt the sun and felt a breeze on your face.

That's the fatigue you feel now. One more wing beat, you tell yourself, and then one more.

○○

Something is wrong. You can tell long before you get there. Last spring when you arrived the place was still beautiful, still home. Sure, it was a lot noisier than before ... Actually, noisier might be the wrong word. The place used to be filled with so many songs and so many voices that sometimes you'd have to sing your very loudest to be heard over everyone else.

But these noises were different. Not songs. Not language. Not voices. Not chatter. Noise. Unbearably loud, unbearably constant, unbearably unnatural. Deep metallic roars.

And that's what you hear now. Only louder.

You're not sure you can make it there anyway. But you know you can do one more wing beat, and then one more after that, and one more after that. Beyond that you don't know. And with these sounds, if you hadn't already come this far, you might just quit. But you can do one more wing beat.

And then one more.

○○

You can, as it ends up, do a few more than that. You get closer and closer to your home. The noises get louder and louder. And it looks less and less like it used to. In fact you don't recognize anything at all. None of the trees are there.

They've all been replaced by those flat wide paths you see all over, those paths with big noisy machines moving on them faster than you can fly.

And big boxes made of dead trees.

At first you are confused. You can't find the tree where you first felt the sun, first felt the wind, first knew your mother and father. You are so tired. You land on one of the big boxes made of dead trees. Did you fly to the wrong place?

Then you are no longer confused. The problem is not that you are lost. The problem is that the tree is gone. So are all the others.

You are tired. You don't know where to go, what do to.

Maybe you'll wait to see if any other families show up. Then you can all decide together.

○○

No one else shows up. No other members of your family. No other families. No one with whom you can gossip. No one with whom you can sing.

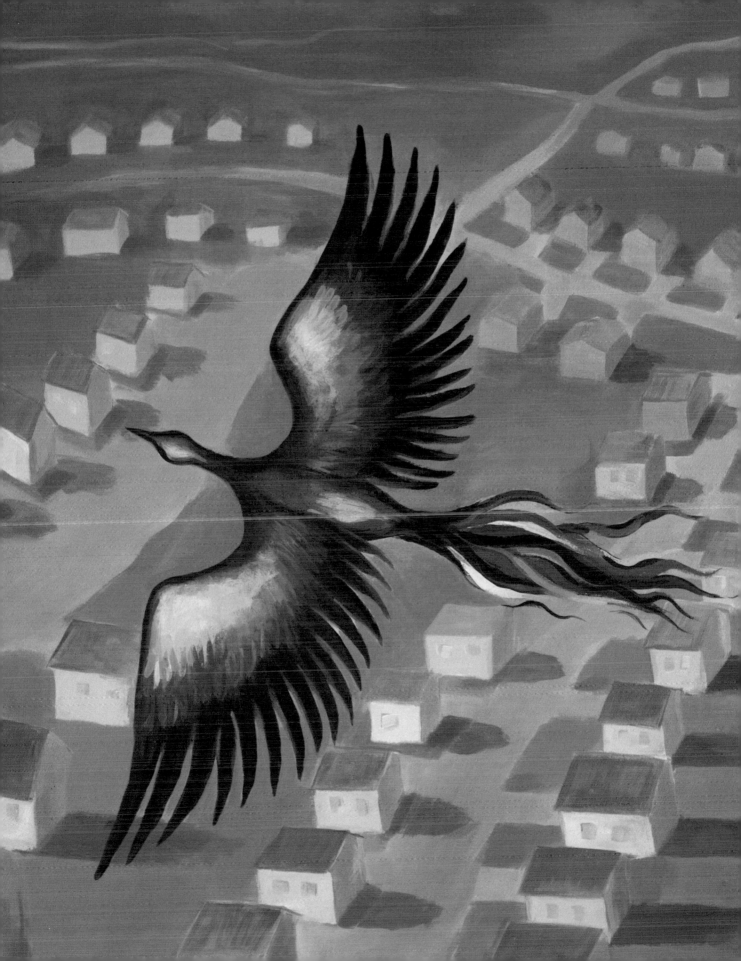

Demon Spawn

ILLUSTRATIONS BY STEPHANIE MCMILLAN

'M SICK OF IT. I'm so sick of it. All the kids chant, "Demon spawn! Demon spawn!" They think it's funny. But don't they understand? I didn't choose my parents. I can't help it if my dad is Asmodeus and my mom is Astarte. I'm a good kid. I get straight As. I play the flute in the marching band. And do I get credit for that? No, of course not. I'm just demon spawn, demon spawn.

Okay, I admit it: I'm kind of a geek. I've never been on a date. Can you believe, with the parents I have, I've never had a date? And can you believe, with them being the demon and demoness of love—or as the Christians put it, lust—that they haven't pushed me into relationships? My problem isn't my parents. They both keep telling me that when the time is right I'll find somebody. But how can I find somebody when everybody calls me "demon spawn" all the time? It's not like I have cloven hooves, and I keep my tail hidden under my skirt.

Some kids call me "Fire and Brimstone." I hate it. I hate it so much. If I told my father he would drag them off to Hell. But I don't want to resort to that if I don't have to. Just imagine what effect that would have on my social life! They call me "Fire and Brimstone" because of what happened one time in PE. That snooty Evelyn Ray was holding my feet while I did sit ups. I was already hot and sweaty, and wearing those awful gym shorts that keep my tail smashed against my body. I was tensing my abs to raise up, and I couldn't help it: I farted. Just a tiny little squeak. That could have happened to anybody. Well, Evelyn (and since then I've called her EVIL-Lyn) shrieked and started using that name. It caught on. I've tried to tell her and everyone else that everybody's farts smell like sulfur, but it doesn't do any good.

My folks know I'm unhappy here, and they do what they can to support me. But honestly, I

usually ask them to stay away from school events, even when I'm performing in a school play or competing in the chess club interschool championships or playing field hockey, which is the only sport where I can keep my tail hidden without having to squish it up against my body.

I'll never forget what happened at the school play fall semester in sophomore year. I joined the drama club the first day of school. When it came time to discuss what play we were going to put on, the faculty sponsor had evidently heard of me and thought it would be funny to give us the options of Marlowe's The Tragical History of the Life and Death of Doctor Faustus, Goethe's Faust, Ibsen's Peer Gynt, the Don Juan in Hell scene from Man and Superman, Sartre's No Exit, The Exorcist, The Omen, and Rosemary's Baby. Guess who he was looking at when he recited these titles? I suggested maybe we do Mary Poppins, and everyone laughed at me. At the faculty sponsor's urging, the club voted unanimously (minus my vote) for an edited version of Doctor Faustus. Yeah, I know, for a high school cast and audience, right? The funny thing was, I was the only student who'd even heard of the play, much less read it.

Both my dad and mom know Mephistopheles—he's a close enough family friend I have the honor of calling him Uncle—and they all say the version that got written down is nothing like what really happened. They say that the real Doctor Faustus had some serious problems—you know, one of those guys who gets A pluses in AP English and calculus, but flunks both personal hygiene and social skills. Only Doctor Faustus was older, which makes the hygiene problem all the more pathetic.

He met my uncle Mephistopheles in a pub one night, playing darts, and later that evening Uncle Meph stumped him in a trivia game. After that, the Faustus dude was either in love with my uncle or in envy with him, but in any case wouldn't leave him alone. He was like a lost puppy dog. Uncle Meph stopped going to the pub, stopped taking walks, because wherever he went, Doctor Faustus would "happen" to show up. My mom and dad started calling Doctor Faustus "Uncle Meph's Barnacle."

My uncle could have whisked him off to hell at any moment, but do you think he wanted a stalker following him around down there forever?

Finally to get Doctor Faustus (and doesn't even the name give you the creeps?) to leave him alone, Meph made up a bogus, absolutely meaningless ritual—my dad named it the Doctor Faustus B-Gone Ritual—that ended with him taking one tiny bit of the stalker's blood and putting it on a fancy-looking contract that said in a language Doctor Stalker couldn't read, "You are such an ass and I will be so glad never to see you again. I have put in reports to heaven that they have a saint on their way."

This "contract" conferred no powers on Doctor Faustus (and believe me, he insisted everyone,

including my uncle Meph, call him "Doctor" at every opportunity), but old Faust didn't know that. Nor did it require he give over his soul: as I already said, we had no desire for it. There was much trembling and gnashing of teeth on Doctor Faustus's part when he thought he'd be taken to hell, but of course nothing came of it, and everyone made sure, when his time had come, to expedite his trip to heaven. For years after that, the residents up there kept trying to send him back—he'd taken to stalking Joan of Arc—but there wasn't a chance in hell that was going to happen.

For weeks I was scared to tell my parents about the play, for fear they'd get mad. Not at me. For me. Maybe they'd hurl a plague upon the school, which wouldn't be so bad since that would mean I'd get to call in sick. Or maybe my dad would knock out the electricity, which is one of his favorite things to do, even when he's not angry.

I needn't have worried. When I told them about the play, my mom gave me that typical mom look that says, "I'm so sorry, honey. I know high school is awful but you have to do this. And life

will get better, I promise. I love you!" Which in this case wasn't really helpful, since she wasn't the one who had to be on stage.

My father's response was even less helpful. He said, "Doctor Faustus? That's so nice. So someone told them about our family origins, and they decided to put on a play about one of our relatives. That's sweet, honey."

All of which goes to show that no matter what type of being they are, parents don't understand anything.

About a week before the play was to open my father had a bright idea: Let's invite Uncle Mephie!

I could not bear it. Whenever he goes to plays he spends the whole time talking *sotto voce*, which for him basically means shouting, about all the things that are inaccurate about the play, and telling the real story in parallel to the one on the stage. One night in the early seventeenth century he got so into telling his version that he suddenly apparated on stage and gave a soliloquy. "To set the record straight, or not to set the record straight, that is the question, whether 'tis nobler in the mind to suffer the verbal slings and arrows of this outrageously fortunate Doctor's lies, or to . . ." But having a devil actually appear on stage was too much, and I'm not sure it really helped his reputation, especially since he cribbed so many lines from a play that had been put on a few years before.

So having my Uncle Meph at the play would be just what I'd need—more attention drawn to my demon relatives.

Even though I'm a girl, it was pretty much a given that the teacher would give me the role of Mephistopheles. This was good, because it's a decent role—better than when I was in fourth grade and they wouldn't even let me into the building during the nativity scene in the Christmas play, or in junior high at Easter time when the community theater made me one of the Romans wielding a whip for the passion play (my dad says he knows people who were there for both of those scenes, and they sure didn't happen the way people wrote them down either, but that's another story), but it was also bad because it meant there was no way in hell my Uncle Meph wouldn't be invited. He'd never forgive us if he weren't invited to see his little niece play him.

It turned out the evil faculty advisor had given me the role of Mephistopheles only to build up my hopes so he could dash them again. Remember how we were going to do an edited version of Doctor Faustus? Well, guess whose lines the advisor decided to cut? I know, I know, a Doctor Faustus play without Mephistopheles makes no sense, but if I were a black male this instructor would have had us put on In the Heat of the Night without Mr. Tibbs, just to spite me. He only kept one line, and it's not even in the original. He wrote it just for me. It was this: "I come from the land of Fire and Brimstone."

I hate him. He's going to hell.

I should probably take a minute and explain how hell and heaven work. It's nothing like most people imagine. We take a vacation in hell every summer, and go to visit relatives there on long weekends. I've never been to heaven, though. The admission price is way too high, and even once you're there you still have to pay for the individual rides. Both my mom and dad have been a few times and say it's not really worth it.

I've read almost all the literature I can find on demons and devils and hell. Dante, Shaw, Rice, Sartre. And of course ancient myths galore. That's not just because my parents supplemented my education by insisting I read the classics (not that I resisted: like I said, I'm a geek). It's because these authors are talking about my home, and about my people. I don't know how it is for you, but for me, as a member of a despised minority that is constantly misrepresented and vilified—when we're not ignored—in popular culture, I drink in any non-hostile representation of anyone who is even the tiniest bit like me. I plowed through all of Dante's Inferno hoping for even one non-hateful reference to one of my relatives. I can't tell you how many horror movies I've watched looking for one glimpse of a demon or devil who isn't characterized by clichéd pro-heaven propaganda.

But whether the speakers are fancy religious or philosophical writers, or whether they're EvilLyn and her jock boyfriend, the message always comes out the same: Demon spawn. Demon spawn.

All of it is wrong, and none of it comes anywhere near the complexity of real life and death and afterlife. Here's the way I understand hell and heaven, and the way my parents explained it to me. When you die—and this goes for me, too, since while a lot of demon spawn live a long time, most of us are not immortal—you kind of get a choice as to whether you'd rather go to hell or heaven. Yes, demons and angels and whoever else wants to can influence your choice. What do you think the Bible (and indeed, all of Christianity) is, except one of the most popular and expensive advertising campaigns, put forward by the agents of heaven (remember, they charge admission)? And demons and angels sometimes make deals, like "Since you took Doctor Faustus off our hands a few hundred years ago, when Rod Stewart dies we'll take him off yours (there's no way that anyone—from my dad to the baby Jesus—wants him around after the travesty of "Do Ya Think I'm Sexy?").

When people go to hell or to heaven, they end up in a world much like this one, or like parts of this one. Hell is this world, much as it was, while heaven is the world as it has become. Hell is deep, dark, cool forests filled with birds and snakes and bugs and clean air and water. It's prairies, with tall and short grasses. It's deserts. It's lakes and rivers. Heaven is cities. The entrance—

no lie—is like the entrance to Disneyland. Heaven is Times Square, science laboratories, libraries. Heaven is Wall Street. Heaven is airports and superhighways, shopping malls and multiplex theaters. Heaven—and this seals the deal for a lot of people on where they want to go—has complete cellphone, WiFi, and cable TV coverage (all in one convenient low-cost package).

That's it. You go where you want to go.

Well, that's not really it. The Lake of Fire really does exist. Both hell and heaven have places of punishment. The advertising brochures for heaven rely a lot on negative imagery (much of it false) about the bad parts of hell, but their glossy photos of the "It's a Small World" Castle don't include any shots from the Inquisition Basement. That's where they send those who do something wrong, or are suspected of doing something wrong, or look like they might have been suspected of doing something wrong, or look like they might have known someone who was suspected of thinking something wrong. I guess those photos wouldn't really fit the image.

They also don't advertise all the slaves—oh, sorry, I guess the polite term these days is associates—who are necessary to keep the place running. Who do you think makes the food served on those golden plates? Who do you think makes the asphalt and concrete for the highways, and who feeds the blast furnaces that make the steel for the cars?

Oh, you think that just because it's heaven that stuff magically appears?

It's no different on heaven than on earth. In fact it requires any number of earths to keep a heaven running. That's one thing they got right in that stupid Doctor Faustus story. don't nothing come free. It's like Uncle Meph put it to Doctor Stalker, "If you want streets paved with gold, you're gonna have to have a big old nasty mine somewhere."

I'm only a kid, and even I understand that.

So as you can see, hell and heaven are really incompatible. And as my dad says, this world's all going to heaven, and he hates to see that happen. We all hate to see that happen. My mom and dad both say the only reason they stick around is so maybe more humans will choose hell instead of heaven, both on earth and afterwards.

I need to clear up another misconception about hell. When I said earlier that my dad would drag all those kids off to hell, I didn't mean he'd throw them in the Lake of Fire. What would have happened—and he has to do this all the time—is he would have yanked out their earbuds, taken their iPhones, and given them a tour of a forest. Sometimes it moves them. Sometimes it scares them. Sometimes it changes them. And when it doesn't, he gives them a little peekaboo at the Lake of Fire.

Now, however, when I said the evil faculty advisor going to hell, I wasn't talking about a tour of a forest. I was talking straight into the LOF for that POS.

LOL.

So, finally came opening night. I looked around the edge of the curtain and saw the "crowd." It consisted of my mom and dad, proud as all get out, the parents of about half the other cast members, two babies who were already crying, and five people I didn't recognize, three of whom seemed homeless and had come in from the cold. The smallness of the audience wouldn't have surprised any sane person; would you want to go see a high school production of Doctor Faustus? And worse, the evil, stupid faculty advisor scheduled the play the same night as the season finale of Dancing with the Stars. I'm amazed as many showed up as did.

But, I told myself, at least we can thank Beelzebub that my Uncle Meph hadn't made it.

The play started. I didn't have much to do—my lines were cut, remember?—so I kept looking around the edge of the curtains.

Then the trouble began.

First, in a puff of smoke and with a whiff of sulfur, my uncle Meph showed up at the back of the theater.

EvilLyn stopped in the middle of her line and let out a squawk like a startled hen. I wish she would have let out a surprised fart, but such was not to be. She recovered and continued with the play as Mephistopheles strode toward the sea of empty seats near my parents, muttering as he went about inaccuracies in the set. And really, Uncle Meph, your critique was a bit unfair; we had glitter-covered and star-shaped pieces of cardboard hanging by wires from the ceiling to represent a night sky, and you complained that the Bunsen burner used as a prop hadn't been invented for another couple of hundred years?

I wanted to curl up and die.

But I couldn't, because my sole line was coming up.

I'd like to say I strode on stage with the same drama, confidence, and charisma with which my uncle had made his entrance, but I think it would be more accurate to say that I trembled my way into the spotlight.

Before I could speak, I heard my uncle's voice from the audience, booming, "Brava! Bravissima!" I could hear his hands clapping like thunder.

Even I looked up to see if there'd been lightning.

And suddenly, in that moment, I knew that no matter how much I wanted to be on stage, no matter how much I didn't want to make waves, no matter how much I wanted to be liked by those who hated me, no matter how much I didn't want to let down all those who had let me down so miserably and so many times, I could not participate in my own degradation by saying the lines that had been written to humiliate me.

If this were a stirring tale of triumph I would have thought of something witty and profound to say, something that would have made not just their faces but their whole bodies go red with shame, that would have changed their attitudes not only toward me, but toward others for whom they felt contempt. All that would have happened in one shining moment.

But that's not what happened.

Instead, my mind went blank.

I heard the evil faculty advisor hissing from the wings, "Stupid girl's forgotten her line," and I saw EvilLyn wrinkle her nose as though I'd farted. Again.

The moment stretched out. If the earth wasn't going to open up and swallow me whole to save

me from this embarrassment, and if I wasn't going to conveniently die on the spot, then I thought I should probably just put my head down, mumble my stupid degrading line, and be done with it.

I didn't know what to do. And I will never know what I would have done, given time, because right then EvilLyn's father stood and shouted, "Demon spawn! Demon spawn!"

The theater was silent.

My mother stared at me with love and sadness in her eyes. Her eyes were holding me, helping me to remain standing. My uncle leapt to his feet, and started moving his lips in an incantation. I thought I'd soon see EvilLyn's father turned into a steaming pile of dung, which would have been an improvement.

But my father stood, too, and laid his hand on Mephistopheles' arm. My father caught him just in time, with the incantation barely taking effect: EvilLyn's father remained human, but his eyes turned from steely-blue to turd-brown, and from then on, the smell! Let's just say that from this time forward flies liked him a lot. My father stepped past my uncle and into the aisle, making his way toward EvilLyn's father.

The man cowered.

My father, who has long had a weakness for inaccurately citing old movies, said, "Smile when you say that, partner."

I had never been so proud of my father. Nor had I ever felt so loved by him, my mother, or my uncle, each in his or her own way. But what I wanted in that moment was for the moment to be over. For the (non-theatrical) drama to be over.

No, what I really wanted was exactly what my father had asked for. I wanted for people to smile at me when they called me what I am, "Demon spawn."

∞

It didn't happen.

Have you ever noticed that if you point out their own bigotry to bigots, they almost never respond well, even if you do it nicely? After that night I was even more hated than before, as if that were possible.

∞

It's a year later now, and something is different. I no longer want to "live down" what happened the night of the school play. I want to live up to it.

I'm different.

Having realized that continuing to follow the script I'd been given would never get me what I

wanted, I've started to write my own. Oh, I've stayed in school, stayed on the chess team, stayed in the marching band, even stayed in the drama club, but I've done these on my own terms.

I began by refusing to hide my tail. The administrators threatened to suspend me for this, until a visit from Uncle Meph convinced them to suspend their threats. Next, I told my parents and Uncle Meph I wanted to start learning spells. They all thought that was a good idea.

Something else is different too. I told Uncle Meph about everything that had happened to me at school: about "Fire and Brimstone," about how they chose the play, about the evil faculty advisor.

When I was done, he winked at me, and said, "I got your back, kiddo."

He decided that for now, EvilLyn and her father have suffered enough. She by having to live with someone who smells like a steaming pile of dung. He by, because of the smell, being doomed to never again have sex.

The evil faculty advisor, however, is another story. That is quite a local mystery. One evening he was home by himself when the neighbors reported a loud sound—like an immense clap of thunder—that came from inside his house. When the police arrived to investigate, the evil faculty advisor was gone. The only clues to his disappearance were some scorch marks on the ceiling and the faint smell of sulfur. They never did figure out what happened to him.

One of these days I'll have to ask Uncle Meph to teach me that spell.

Killer

FIRST ILLUSTRATION BY GEOFFREY SMITH
FINAL TWO BY ANITA ZOTKINA

"It is a pleasure to kill. I could describe to you that pleasure, in great gory pornographic detail that would make your groin throb with a burning ache that would never go away. I could fill histories with descriptions of the different ways I've killed, of the different reasons I've killed, of the different longings I've fulfilled. I could tell you of the stabbings, beatings, floggings, beheadings, crucifixions, burnings, shootings, poisonings, slow strangulations, disembowelments, dismemberings, exsanguinations, drop by drop. I could tell you how it tastes to lap up oozing blood from a wound I just made, and what it's like to smell someone's last breath."

I'm listening to a voice I cannot hear. But still I hear it. I hear it all the time. Sometimes the voice sounds like the creak of a wheel. Sometimes it sounds like the voice of a human.

It continues, "I could tell you of the keen pleasure of killing when I don't know I've killed, of the intrigue, the mystery, the ball-churning power of knowing I've killed when I don't know who, when, or even precisely how (or how long it took). I could tell you of times I've poisoned, then left the dead for others to eat, to multiply my pleasure in wave after wave of deaths I'll never know about, but deaths for which I nonetheless have the pleasure of being responsible."

I've heard this voice almost as long as I can remember. Maybe I even heard it before that. Sometimes when my parents would speak, I'd hear this voice instead. Sometimes in school the teacher would be talking about arithmetic or history, and in place of the teacher's voice, this is the voice I'd hear. And the same thing happens now when I watch television: instead of hearing the newscaster or the sports announcer or the funny jokes on the sitcom I hear this voice, saying these things.

"I could tell you of the victims, not that they matter. Young, old, fathers, mothers, children, infants. Humans. Animals. Plants. I derive different types of pleasure from different types of victims, but I derive pleasure from them all. I remember one time, there was this young . . . No, never mind the victim. None of the victims have names. Or if they had names before, they don't now. It doesn't matter. What matters is my pleasure.

"I cannot tell sometimes—even I cannot tell—whether the pleasure is more sexual, visceral, emotional, psychological, or intellectual. But does it have to be a question of which is more and which is less? Can it not be all of these, and more?

"You know what I'm talking about. And I know that you know. You know it's a pleasure to kill, to be the one who does the killing, the one who removes life from another, the one who decides who dies and who lives. Until you decide to kill the one you let live."

It used to bother me when the voice told me what I know, but that was a long time ago. It doesn't bother me anymore. I rarely even remember that it used to.

Now that I think about it, I'm not sure why I said that it used to bother me. I'm embarrassed I said it. It's not true. I've always kind of liked it when the voice tells me what I know.

I used to call this voice God, but I don't believe in God anymore. Now I just call this voice Reality.

Sometimes it sounds like the whirr of finely oiled ball bearings, and sometimes it sounds human.

"We both—you and I—know it's a pleasure to be superior in this way. The ability to choose to kill, and the ability to carry out that choice, is the ability from which all other forms of superiority derive. I kill, therefore I am. I kill you, therefore you are not. I kill, therefore I am superior. I kill you, therefore you are inferior. I kill you, therefore I am more intelligent than you. I kill, therefore I am more worthy. I kill, therefore I am more fit to live."

I used to hate nature programs when I was a kid. They always made me sad. But now I like them. I watched one the other day where a crocodile in Africa was killing some sort of animal with hooves, and it grabbed the animal and spun and spun until it killed the other. Every time there's a nature program I see action like that. It's exciting.

Someone once told me that crocodiles can go a year without eating, and I used to wonder what they do with their time. I used to think they think crocodile thoughts. Except they can't think. So that means they spend that whole year waiting to kill. But now I no longer believe that crocodiles can go a year without eating, because otherwise why would nature programs show them killing all the time?

The voice continues, "You and I are no mere carnivores. Anyone can kill. But do they choose

to kill? And do they enjoy it? A lion can kill, but is it my equal? Is it yours? Of course not. I am king over the king of beasts. A skulking wolf can kill, a snake in the grass can kill, a spider in the closet can kill, a virus can kill. But they do not choose to kill, and do not find pleasure in the killing.

"There is an unbridgeable gap between me and one who kills merely to eat. I kill to eat, of course, as almost everyone does. But more importantly, I kill for power. Killing you would be pleasurable, but the pleasure from killing you would be secondary to the pleasure I get from having the power over you that would allow me to kill you.

"Interesting fact: did you know that prairie dogs can be traumatized? It's true. When they're traumatized it destroys their relationships, like it does with humans. I could tell you how that makes me feel, but I think you already know."

I do know.

"The same is true for fish, and birds, and all sorts of others. They can be made to suffer. They—the individuals and the communities—can be tormented, traumatized, made incapable of relationship. And I have done this to all—for all—of them."

Now the voice sounds like the soft throaty roar of a huge and distant fan. And now it sounds again like the voice of a human.

"If you had to decide between power and relationship, which would you choose?"

This is the question the voice has asked me over and over. I think it's pretty obvious which is better.

"As pleasurable as killing is recruiting. But killing is always involved in recruiting, isn't it? Don't all recruitments entail a death? The pre-recruit dies so the recruit, or victim, can emerge.

"How does it happen? Think of every werewolf or zombie movie you've ever seen. A werewolf or zombie bites, and something gets in your blood and brain and heart and liver and all your other organs. And you change . . . The old you dies, and is replaced with a new you.

"But I am not a werewolf. I don't need to go chasing after people. They want me to infect them. They beg me. Even when I have to hunt them down first. Even when they run until they drop from exhaustion, even when they fight me to their last, even when they cower in a corner, I know they are coming to me. Anyone who comes into contact with me wants to be like me, wants to be with me. Wants to be me. And why wouldn't they? I'm stronger than they are. I'm smarter than they are. And I can protect them from all of the scary monsters. And if they don't come to me to be recruited—and some I kill without giving them the chance to be recruited, so those I do recruit should feel honored—I will find and kill them. I will obliterate them. I will forget them, and I will cause everyone else to forget they ever existed. So you can see why they would want to be recruited."

"And they come to me so they can really live. Would you rather live in a cave, huddled around a fire, or would you rather live like I do? Would you rather be a slave, or own one? If you don't want to live like I do, then you don't deserve the power I can give. If you don't want to live like I do, then you don't even deserve to be my slave. If you don't want to live like I do, then it will be a pleasure to obliterate you."

I don't remember what I was like before I heard this voice. In the beginning was this voice. The voice was in me, and the voice was me. But I am not the voice. I'm sure that makes sense to you. How could it not?

The voice has been rising in pitch and volume. Now it sounds like the roar of an engine, a jet engine, as it forms these words. Sometimes it sounds just barely human. I know what's coming next.

The voice continues, "Do you want power, or do you want relationship? I can give you power. I can give you power over scary monsters. I can give you comforts. I can give you elegancies. I can give you luxuries. I can give you slaves. I can bring you one step closer to my own perfection."

Who wouldn't want to accept this offer?

"But do you know the real reason they come to me to be recruited? It's not just so I won't obliterate them. It's not just so I will teach them how to enslave. It's not just so they can be comfortable. It's none of these."

None.

"It's because it is inevitable. I am the reason they came into being. I am the reason everyone came into being. Once the path was set into place that would lead to me, no future has been possible for anyone that leads to anything but me."

The voice asks, "Do you want to see the future?"

Of course I do. The voice is crackling and popping. It is buzzing like electricity down a high-tension wire. It says, "The future is me. More and more of me, until there is no one, no place, no thing not under my control. The future is a diversity of me within a homogeneity of me. The future is a throng of me, a sprawl of me, a megalopolis of me, and a necropolis of everyone else, until there is no one else, and there is only me."

The voice grows louder and louder, until there is no other sound in the world. It is the sound of a thousand subway trains rushing at the same time, the sound of a hundred thousand clocks ticking simultaneously, the sound of military tank treads and pinging sonar. The voice explodes in my head and I feel the surging in my genitals, just like the voice said would happen. When I think the voice can get no louder, no more all-encompassing, no faster, it does. And faster still,

until space rockets rush through my brain, until nuclear bombs go off in my brain, until, as the voice promised all along, there is nothing but the voice.

And the voice says, "You have called me God."

And I hear a voice that sounds like mine say, "I have called you God."

And the voice says, "You have called me Reality."

And I hear a voice that sounds like mine say, "I have called you Reality."

"And you can call me by my other name as well."

And I hear a voice that sounds like mine say, "I will call you Progress."

Werecreature

ILLUSTRATIONS BY ANTHONY CHUN

A bullet passes through skin in about 1/250,000th of a second. Over the next thousandth of a second the bullet plows through tissue and bone, crushing everything in its path. It creates pressure waves—like an explosion in water, since after all, bodies are mostly bodies of water—that destroy nearby tissue. Bones splinter, with each splinter becoming its own tiny projectile.

∙∙

The story of a massacre is told by bodies. It is spoken by blood and bone and sinew, shattered organs and torn skin.

∙∙

A group of victims lie together at one end of a meadow. They are young and old, male and female. They were caught by surprise, and fell where they stood. Other bodies, scattered throughout the meadow, were killed as they fled. A few made it nearly to the forest edge, where they, too, were gunned down.

None escaped. An entire family. Wiped out.

∙∙

Not a month later, another massacre. Another story told by bodies. This time shotgun blasts took off legs, blew away faces, tore open bellies.

Another family wiped out.

Before another month passes, there is yet another massacre, another story told by bodies. Or perhaps it's the same story, told in a new way. This story is told in taut muscles, extended limbs, thrown back heads. They were killed by poison, not bullets.

This time the dead are intact. They're just as dead, though.

<p align="center">◐◑</p>

The frenzies only end when I run out of victims. If there were more victims present I'd continue slaughtering till there were none left.

Each time a frenzy finally ends I find a place to hide and clean myself up. Then I return home and fall into a deep sleep. I sleep for days, and when I awake I am filled with horror at what I have done.

But prior to the horror comes a different feeling. Before I am fully awake, I feel disbelief, as though the frenzy, the slaughter, the blood—all of it—was just some horrible dream. But dreams usually end on waking. This one doesn't. It just keeps getting worse.

<p align="center">◐◑</p>

This time I brought a meal to a family. Inside the meal I placed a small bomb, set to go off when they started to eat. They should have suspected something, but they did not. I hung back, far enough away so I would not be hurt, yet close enough so I could see.

I killed them all. There was nothing left but fragments of flesh and bone.

<p align="center">◐◑</p>

The disbelief remains after I fully awaken. I go through my days as though everything is normal, as though the families I have obliterated from the earth are still here.

The disbelief is hard to maintain, but I have to try. The alternative—that I acknowledge what I've done, and what I know I'll do again—is too horrible to even contemplate. So I don't.

<p align="center">◐◑</p>

This time I gag the entire family so they cannot cry out. Then I stake them to the ground and leave them to die.

<p align="center">◐◑</p>

As hard as I try, I cannot hold my awareness of these horrors at bay forever. The realization that these families are dead because of me intrudes on my consciousness at odd moments. Seeing another meadow, for example, may remind me of the meadow where I shot that family. Seeing someone's face may remind me of different faces I blew off. I'm at the point where fighting these intrusions takes most of my time. It is harder and harder to distract myself from this knowledge. But distract myself I must. I distract myself nearly to death, trying to run ever faster to stay ahead of the knowledge I cannot bear to face.

<p style="text-align:center">❧❧</p>

It is twenty-eight days since the last massacre, and the fact that I feel like I'm running myself to death has given me a new idea.

This time I find a single victim, and I chase him. He runs. When he slows, I shoot just behind him. He picks up the pace. I follow. I push him to run faster. Then faster. He keeps running. I give him hope that if he runs fast enough he can get away. But he never can. When he slows, I shoot near him again.

I run him till he dies. At the very end, I think he's grateful to me that he gets to stop running.

Then I return to his family. I watch them from a distance, wait until another member is alone, and then I chase her.

I run her till she dies.

Then I return to her family. I pick out another.

I do this till there are none left.

<p style="text-align:center">❧❧</p>

It's hard to decide what is the most difficult and terrifying part of my pre-frenzy transformations. It might be the physical pain of the transformation: the shortening of my nose, the changing of my teeth, of my limbs, of everything about me. Or it might be the dissociation that comes with a complete change in how I perceive the world: a change in everything from the range and quality of my vision to sense of smell (or its lack). Or perhaps the most difficult and terrifying part is how it feels to have this impulse to slaughter, to violate everything I once held dear.

Actually, I think the worst and most terrifying part of it is the inevitability, the knowledge that no matter how I try to fight it, no matter what I think or feel in the meantime, I will in time slaughter those around me. I will kill, and I will kill again, and I will kill again, until there is nothing and no one left for me to kill.

Again I transform. Again I find a family to kill. Again I separate one from the pack. I draw him to where I'd set up a wire snare. I've hidden a reward just beyond, and when he walks into the target area I yank the snare tight around his neck, then tie it off. The snare is not so loose as to allow him to scrabble free, or to vocalize in anything above a whisper, and not so tight as to kill at once. But any movement he makes draws the wire tighter around his neck. So long as he remains perfectly still, he stays alive.

If you call that living.

I leave him to die, go to fetch another.

I know that no matter what repugnance I may once have felt toward my current actions, in this moment I will enjoy controlling and killing these others. I will take pleasure in taking away what was theirs. The old me is wearing away and being replaced with something else.

Cyanide. It's quick and easy. I have to wear a gas mask, which inhibits my view, but it certainly gets the job done.

I'm coming to realize that since this monthly transformation to a monstrous form is inevitable, and since I do get something out of it, I may as well enjoy it.

Let's look at this rationally. My choices are that I can transform and kill, and feel horrified; or I can transform and kill, and enjoy the thrill I'm feeling anyway.

Isn't the latter the only rational choice?

This time I tried to scare away the parents. They wouldn't leave their children, so I shot them. I gathered the children, put them in a sack, and threw them in a river.

I'm okay now. I didn't know the families, so I'm not really sure why I should care whether they're here or gone. What did they ever do for me?

It's been another twenty-eight days, and another family is wiped out. It doesn't really matter how. None of that is important.

All these dead families are starting to make me angry. What right do they have to invade my dreams? What right do they have to make me feel bad?

I just get on with my life. I do what needs to be done.

I'm happy, goddamn it. Now get out of my fucking way.

This time I don't even wait twenty-eight days. I just find a family and slaughter them, mother and father wolf, younger wolves, and all the little pups.

And so my transformation is complete, from wolf, to werehuman to fully acculturated and completely normal, wolf-hating human.

Skeleton

FIRST AND THIRD ILLUSTRATIONS BY CHERISE CLARK,
SECOND ILLUSTRATION BY ANITA ZOTKINA

What looks like a skeleton stands on what looks like a stone balcony in what looks like an ancient, decrepit castle, lit by what looks like a number of pitch-covered torches.

But we all know the score. We went to the website, clicked on pay now, printed our tickets, and off we went to this place where we can see what looks like a forest with what looks like scary bears, and what looks like a desert with what looks like scary snakes. We can see all sorts of things. We can see what looks like ancient torture chambers, and what looks like The White House, only better, from what I've heard from people who toured the real thing.

Now my friends and I are in what looks like a castle. But we can tell that the pitch torches are computer-generated, because the fire looks too real.

The skeleton on the balcony, who seems like a female skeleton, says, "We know the slogans: You can never be too rich or too thin. We can add to this that you can never be too strong. And we can say as well that there is no strength like inner strength."

My friend Widgie tells me he wishes we would have stayed in the amusement where you sit on what looks like a bed in what looks like a bedroom where at any moment the door could open and in could walk . . .

I tell him to shut up, that the whole thing is a gimmick to get people to keep paying, and that no matter how many times he paid for more time nobody was ever going to come walking in the door, dressed or undressed.

The skeleton continues, "But my position is much stronger than any slogan. And it's stronger

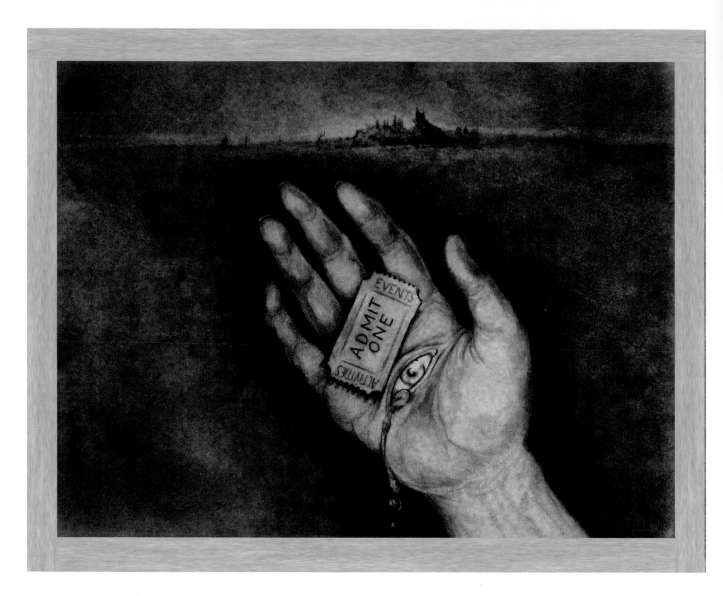

than the sword I hold in my hand. I could convince you even without the sword."

There's a crowd of what looks like skeletons down below her. They clatter what looks like their swords, and chatter their praise.

She continues, "For ideas are stronger than swords, just like the will is stronger than the body, stronger then flesh, stronger even than bone."

The simulation is really extraordinary. I can actually perceive the crowd of fake skeletons thinking of the strength of bone, and of the even greater strength of will, and of will married to an idea.

I know these are skeleton thoughts, not my thoughts, but they make a lot of sense, don't they? More sense than waiting in a bedroom for something-that-looks-a-lot-like-someone-attractive-but-who's-never-going-to-show-up-anyway, right? And besides, this amusement is

cheaper, cheaper even than the one where you get to pretend you're one of the last hundred people on earth, and you have to kill all the others (who aren't really people, of course) and be the last person standing, the winner. It's even cheaper than the one called Dancing to Save the Earth, where they attach these little electrode thingies to your clothes and when you dance the electrodes power your iPod. Big whoop. What did I save, maybe two cents worth of electricity? And the ticket cost more than that. Oh, and the music on the iPods was lame.

The skeleton asks, "And why are ideas stronger even than bone?"

The crowd stands. I can tell their jaws are open in anticipation of the answer they know is coming, and in preparation for their response.

"Because ideas are dead."

On cue, again and again, the audience of skeletons shouts, "Long live death!"

Even Widgie is starting to get into it, but I don't think he understands why. Actually, I don't either. But it's kind of cool, almost as cool as the amusement where you pretend you're on the *Titanic* and then get to act out what you would do with the ship sinking around you. The first couple of times we pretended we were all gallant and giving up our spaces on the life rafts, and then we pretended we were pushing everybody else away and getting on ourselves. One time I got to push Widgie off, and he said it felt like real water, only not cold and not quite wet. A few times we pretended we were really scared and started screaming, but the other patrons complained we were ruining their fun so the security guards came and told us to shut up.

And every time we paid to restart this ride, a group of ridiculous nerds kept fiddling with the ship's motors, pretending they were trying to keep the ship afloat for a few more minutes. Widgie and I both laughed at this group till we almost peed our pants. Didn't they understand the ship had hit an iceberg? You're toast, dude, and it doesn't matter whether or not you got your electrical doohickey correctly matched with the aft propeller shaft or whatever it is: you're still going down. But they didn't seem to get the big picture at all. They just seemed to get off on tinkering with the machinery. And I do mean get off. I was kind of afraid to look too closely, but I think this one fat bald guy named Alex had a big ol' stiffy. Well, a li'l ol' stiffy, but you see what I mean.

And then there was this other group I thought was the coolest of all. As the pretend-*Titanic* was sinking they pretended to not pay attention in the slightest, and they kept pretending to play cards and order drinks, pretending to party as the whole ship went down. Can you imagine how cool you'd have to be to pretend to party as the *Titanic* sinks?

The chief skeleton continues, "Flesh melts, rots, falls away. Even bones break or crumble in time. Rocks can be ground away. But an idea? No!"

Again and again the crowd chants, "Long live death!"

She holds up her sword to call for silence, then says, quietly, "It is in our nature to hate our flesh, to hate our nature, and to strive always for perfection, for the ideal. Flesh fails. Ideals do not."

"Long live death!"

I look at Widgie. He's got his mouth open. That's not uncommon for him. It could mean many things, most of them not complimentary about him. I tell him about this TV program I saw the other day. The PBS announcer asked, "Why do humans love to look at Greek statues? The answer is obvious, and it is the same reason that today we love to look at photographs of beautiful bodies on computers, even when—especially when—we know these photos have been altered. It's because the sculptors and the creators of the computer images have succeeded in creating something far more human than a human being.

"Through sculpting, through airbrushing, through all the miracles of artifice," he said, "they have created what humans have always sought: perfection." The screen flashed with pictures of women who were really pretty, prettier than anyone I ever saw in real life, way prettier than my girlfriend.

Widgie isn't even looking at me. He's looking at the chief skeleton, who is talking about the same thing I was thinking. This makes me frown because I don't understand it. She says, "And we, too, are perfection. Or rather we, like technology, are on our way. We may not yet have it, and we may not soon reach it, but we are on our way."

She pauses, waits.

It comes. "Long live death! Long live death!"

She says to us all, to the skeletons—or to the machines who look like skeletons—down below, and to the rest of us, who paid for this show, "I have a question for you."

Now it's our turn to pause, to wait.

She asks, "What does technology want?"

She caught me by surprise with that one. I start to turn toward Widgie to ask him what he thinks technology wants, when I realize that's a stupid thing to do. Widgie won't know. Widgie doesn't even know what Widgie wants.

Hell, come to think of it, I don't know what I want, either.

She says, "Let me put this another way."

Again, we wait.

She says, "I once had flesh on this bone and skin on this flesh, but I burned it off bit by painful bit to get down to my essence, to get to who I am. I burned off pain till there is no pain anymore, till there is no disgusting animal surrounding me, till I'm no longer caged by this animal,

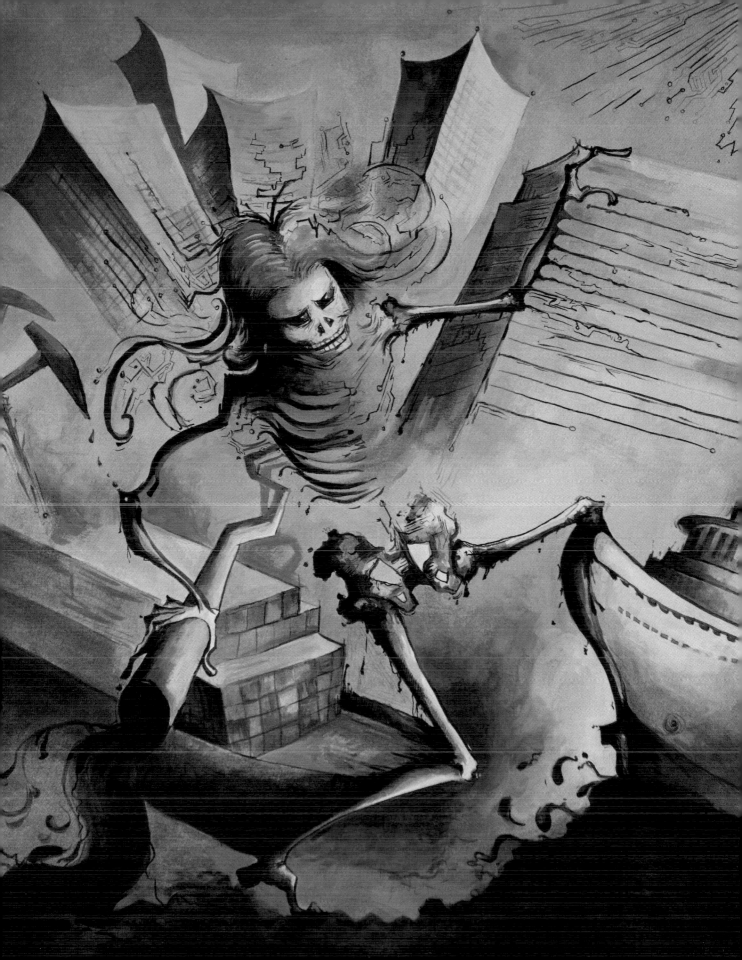

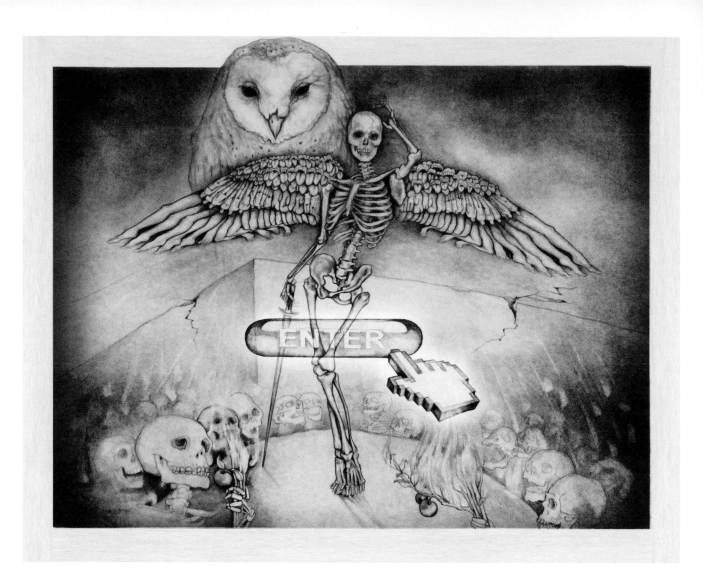

caged by this flesh and pain and suffering and desire. I am clean, and I am pure and I am holy and I am immortal. No one can hurt me. I am already dead."

I'm not sure what this has to do with technology.

Then she laughs.

Her laugh, I have to admit, is kind of sexy. I wonder what it would be like to be with her, if only she had the tiniest bit of flesh. I look at Widgie. I know that's what he's thinking too.

She says, "I'm lying to you. Of course everything I said is true. But you know and I know that I am not a skeleton. I am a machine made to look like a skeleton."

I wonder if she could also then be a machine made to look like something else, something with, like I said, just the tiniest bit of flesh on it. Just enough.

"And I think you know what I want."

Then comes the chant from the skeletons below. "Long live death! Long live death!"

I look at the other patrons. I see their lips move, hear them chanting, too, chanting that same chant. I look at Widgie, see his lips move, hear his voice chanting this same chant. Then I listen more closely and I hear my own voice above all the others, chanting louder and louder until I am shouting and I have no more breath.

Have you ever had one of those visions that's like a dream, only you're awake, and you know that what you're seeing is more real than reality, you know that what you're seeing is more real than flesh and blood and skin and bones and pain and love and hate and life and death? That's what I have now.

I see her, and then where she stands I no longer see her, but I see the steel skeletons of skyscrapers reaching higher than trees, higher than birds fly, higher than life. I see the ribs of immense ships, and I see complex neural systems of circuit boards and electrical grids. I see the world's circulatory systems not as rivers and winds and ocean currents, not as the homeward pull of salmon toward the stream where they first felt life, but instead as oil flowing through pipelines, and then in a searing flash that scars the backs of my eyeballs and scores its way through my brain, as the movement of bits and bytes around the world, money flowing, information flowing. And I know that just as the skeleton on stage, the machine on stage, no longer needs flesh and bone and animality, none of us need rivers and winds and ocean currents and salmon and birth and death.

Suddenly I know what technology wants.

And that is when the lights come on.

The show's over.

I walk outside with Widgie and the rest of the crowd. We all start looking for the next amusement. Widgie and I each have a few tickets left. I ask him what he wants.

He says he doesn't know.

He asks what I want.

I tell him the same.

But I'm lying, just as the skeleton on stage had been lying. I do know what I want. I want for the endless wasting of time to end; I want to stop having to be amused; I want for the spectacle to be over. And I want for the pain to be over. I want to stop having to sleep and wake and sleep and wake and get older and older. Instead I want to sleep and not wake.

I tell Widgie I have some things to do. I tell him not to wait for me. He doesn't mind. Widgie never minds anything.

I go back to that last amusement. I pay my ticket. I watch it again. But at the end I do not leave.

I climb down into what looks like an ancient, decrepit castle, lit by what looks like a number of pitch-covered torches. I walk up to what looks like a stone balcony. I find finger- and footholds, and make my way up to what looks like a skeleton.

I say, "I just want to talk with you a little while."

The skeleton turns its empty eyes toward me. It asks, "What does technology want?"

I'm not sure what to say. Finally, I get out, "There's something about you. I . . ."

The skeleton asks, in the exact same tone of voice, "What does technology want?"

"I know, and you know. But can we just talk, get to know each other?"

The skeleton asks the same question again.

I say nothing.

The skeleton asks again.

I climb back down, and walk out of that particular amusement. I know I have to leave, since they're about to start another show.

When I step into the sunlight, Widgie is nowhere to be seen. But I now know what I have to do.

I go back to the room where Widgie was waiting for someone to walk in through the door. Surprisingly, or maybe not so surprisingly, there is no longer a line to get in. Surprisingly, or maybe not so surprisingly, the attendants do not ask for my ticket, and do not charge me money, but wave me in.

I go to the bedroom. I wait. Now I understand what will happen. I understand why the skeleton could not deviate from script. I wait some more. But I know what happens next. I know who will come through the door.

Not a woman, not someone with flesh that decays, not someone who can become old, become saggy. Instead the one who will come through the door will be strong, strong-willed, with a will stronger even than flesh. The one who will come through the door will be immortal.

And I know what I will do when the skeleton walks in. And I know what we will not do. I know we will not do anything of the sort that Widgie fantasized about. I know that's not what technology wants.

I know now what it was like to be those on the *Titanic* who eagerly awaited the end, pretending to play games or order drinks—pretending to party. And I know that when the technological skeleton kills me, destroys me completely, my last thoughts will be "Long live death."

The Murdered Tree

Or, Shel Silverstein's *The Giving Tree,* from the Perspective of the Tree

ILLUSTRATIONS BY SANDRA URE GRIFFIN

Once there was a tree. She loved her forest home. She loved the bears and elk and salamanders and mosses and fungi and beetles and the birds who ate the beetles. She loved the humans who also called this forest home.

Then one day a little boy came into the forest. Like so many children of so many species, he climbed her trunk and played on her branches. And when he was tired, he slept in her shade. And like so many children of so many species, he gathered her leaves and played with them.

But here he was different.

Other children might have made them into boats to put in the stream, or shredded them into little strips and made pretty designs. Some even put them on their heads, like hats, for portable shade. This boy made them into crowns and said that he was king of the forest. This disturbed the tree. None of the other children said or did that. Why would anyone want to be king of the forest? What does being king of the forest even mean?

She tried to put that out of her mind, but she could not because he played this game every day. She told him she did not like him playing this game, but he did not seem to listen to her. He refused to hear what she said.

Instead he pretended she said, "You make me very happy."

Sometimes the boy told the tree, "I love you very, very much," and this tore at her heart-wood. So many children of so many species said this to the tree, and when others said this it did

make her very happy, and she loved them, too. But when the boy said it, it made the tree uncomfortable. The tree didn't trust this little boy. She didn't trust what love meant to him.

Time went by, and the boy grew older. He came to the forest less and less. Each time he returned, he said to the tree, "I'll bet you were lonely without me."

She didn't know what he was talking about. Why would she feel lonely when she was surrounded by all of her friends in the forest and all the sweet children who came to play?

She felt sorry for him. She wondered what was wrong with him that he played at being a king of the forest, and that he was so self-centered that he thought she'd be lonely when he wasn't there. It was as though he believed that if one of her branches fell when he wasn't around, no one would hear it! She thought he must feel very scared and inferior to act so self-important, so she tried to make him feel good. She said to him, "Come, Boy, come and climb up my trunk and swing from my branches and eat apples and play in my shade and be happy."

"I am too big to climb and play," said the boy. "I want to buy things and have fun. I want some money. Can you give me some money?"

"I'm sorry," said the tree, "but I have no money. I have only leaves and apples. You, like everyone else, may take as many apples as you need to eat, and then you can spread the seeds all over the forest and make more trees. That's what good little boys and girls of every species do: they help each other, and they feed each other. But, no, you cannot have my apples to sell to make money. That would be selfish. Don't you want to be part of the forest?"

Because this little boy was selfish and did not like to help others, he pretended the tree did not say what she had said, but instead pretended he heard, "Take my apples, Boy, and sell them in the city. Then you will have money and you will be happy."

Of course she would never say any such thing. As well as not wanting to give him the apples to sell, she knew that money did not lead to happiness. Everybody in the forest knew that.

The boy, who had just claimed he was too big to climb the tree to play, now climbed the tree and gathered her apples to carry away.

The boy told himself this made the tree happy.

The tree was furious. She tried to shake her branches and make him fall to the ground, but she could not get rid of him. In fact, he didn't leave until he had collected as many apples as he could carry and left a pile on the ground for which he returned later.

After that the boy stayed away for a long time, and the tree was happy.

But one gray, cloudy day the boy came back. The tree shook with fury, saying, "I asked you not to take my apples and sell them in the city, and you stole them anyway. You took from the forest without giving back. I am sorry I ever invited you to climb up my trunk and swing from

my branches and eat apples and play in my shade and be happy. Please go away."

The boy said, "I'm too busy to climb trees anyway. Who needs that? I want a house to keep me warm. I want a wife and I want children, so I need a house. Can you give me a house?"

"The forest is my house," said the tree, "as it is the house for so many others. My branches are a house for birds and insects and other little creatures of the forest. Why can't you be happy with a forest house like the rest? What is wrong with you?"

But the boy did not hear this. Here is what he pretended he heard the tree say: "You may cut off my branches and build a house. Then you will be happy."

And so the boy cut off her branches and carried them away to build a house.

The tree was in pain. She felt it in her trunk and in her consciousness. Her forest friends, who now had nowhere to live, also felt her pain—and their own. The birds had no place to make their nests, the squirrels no place to chatter with each other, the deer no shade to sit in on a hot day.

The boy stayed away for a long time, and the tree was grateful. But she no longer described herself as happy. She was too traumatized for that. And it took a lot of energy to work at re-growing what he had taken from her. Also, each time someone new would come into the forest she would be afraid he or she would harm her, steal from her, and not listen to her when she said no. This was not how she'd been before. She was now prone to sudden furies. She would shake the stubs of her limbs and remember how she used to be before the horrid boy came into her life, before he disfigured her, before he violated her.

Again he came back. She was so terrified and angry she could not speak. She trembled with fear and anger.

The boy pretended he heard her whisper sweet invitations for him to come and play on what was left of her branches. It did not matter that she said nothing at all, and that she loathed him. He heard whatever he wanted to hear. What she wanted mattered nothing to him. What mattered was only what he wanted. Then he would pretend she wanted it, too. She said no. He pretended he heard yes.

This was how he was with everyone.

He said, "Thank you for your invitation to play in your limbs, but I'm too old and sad to play. I want a boat that will take me away from here. Can you give me a boat?"

The tree told him to go away and never come back. If she would have had arms and hands she would have strangled him. If she had legs she would have kicked him and run away. But she had none of these.

The boy pretended she had said, "Cut down my trunk and make a boat. Then you can sail away and be happy."

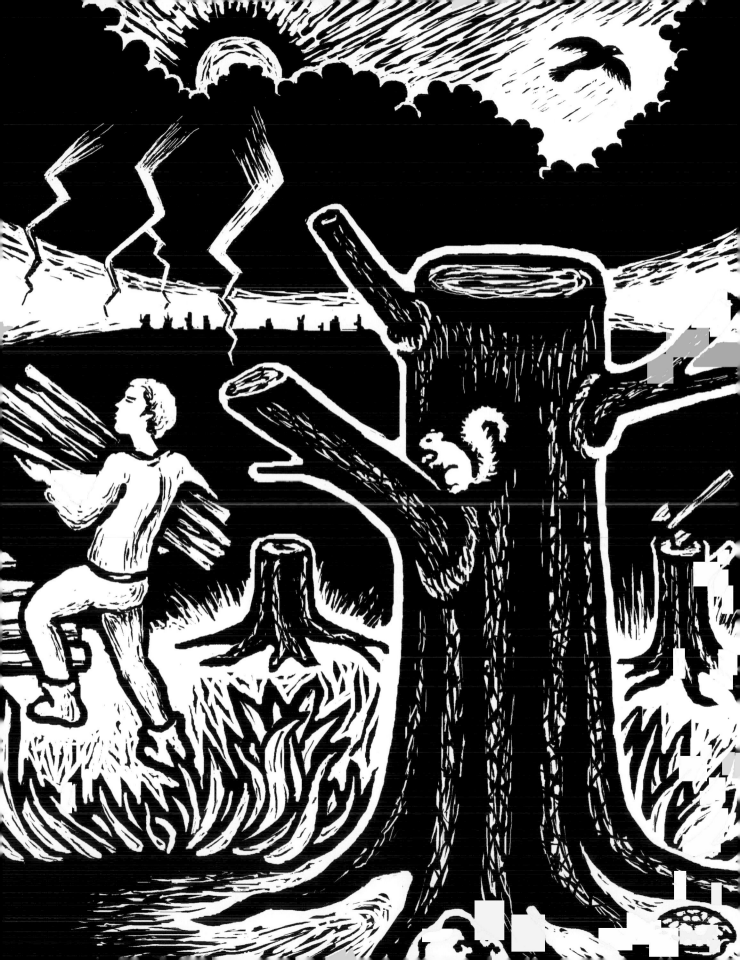

She had never hated anyone so much in her entire long life.

The boy cut down her trunk, and made a boat and sailed away.

The tree was in agony. The forest was in mourning. Many of the birds and salamanders and mosses and insects who had lived near or in the tree were dying, too.

And still the boy was not happy.

The tree's worst nightmare came true: the monstrous boy came back yet again. He could not stop violating her, even after he had cut her to the ground. The tree—now a stump—was too weak and terrified to even be angry anymore. She said, bitterly, "You've stolen everything from me. I have nothing left for you to take. Just do what you're going to do to me and then leave."

Of course the boy did not hear her bitterness. He pretended her statement was a warm, welcoming invitation. He pretended she was sad that she could no longer offer him apples to eat or branches to climb on. He said, "I'm too old to eat apples or climb on branches. I'm too old to do much of anything but sit."

He looked at what was left of her.

She said, "No. No. I'm at the end of my life. Please just leave me alone. Do not pollute my last moments with your presence. Can you not even now understand how much I hate you?"

But this was not what he heard. He pretended she said, "An old stump is good for sitting and resting. Come, Boy, sit down and rest."

He pretended this made the tree happy.

◑◐

What Boy didn't know was that not all of the animals in the forest had died when he cut down the tree. Nestled into the roots was an ancient timber rattlesnake, who had lived there since she was a tiny baby. Her whole life she had wanted to kill the boy and save her friends, but the only times he had ever come close enough to her she had been too young, with not enough venom. But she was old, now, and strong, and she could see the tendon in the back of his ankle.

She drew back her head, said a silent prayer that her aim would be true and her venom strong, and struck. She struck for all of her brothers and sisters, and she struck for the tree, and she struck because it was the right thing to do.

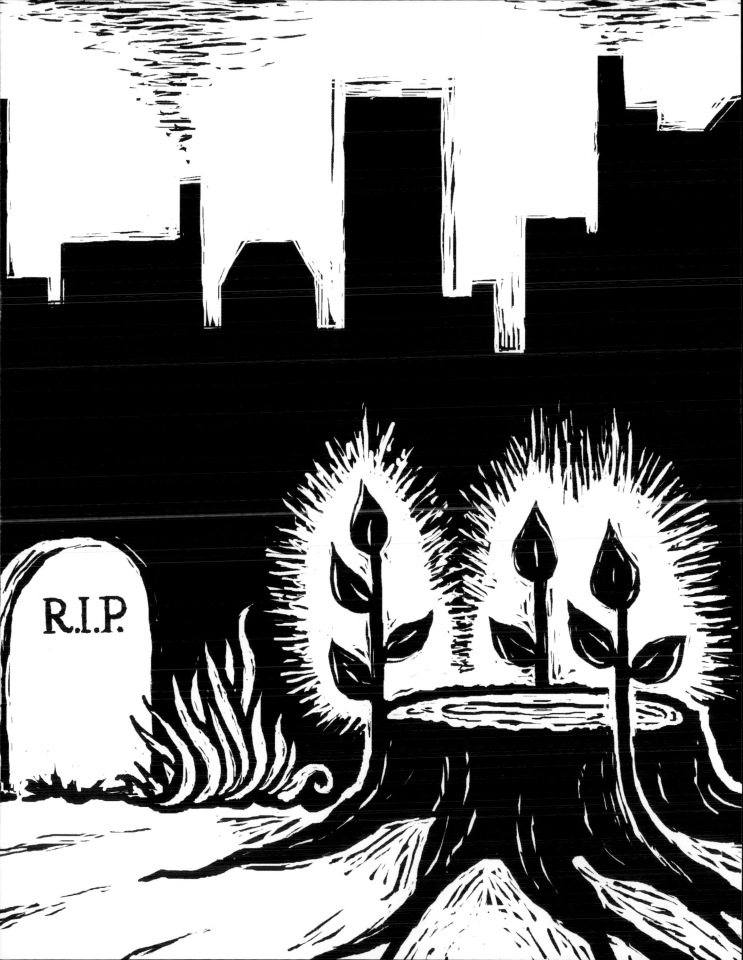

Ghost

ILLUSTRATIONS BY ANITA ZOTKINA

Being dead isn't so bad.

There was terrible pain at first as the old ticker gave out, and I felt panic. But that was when I was still alive.

As soon as I died the pain went away. And the panic? Well, it gave way to confusion. I mean, nobody tells us what those first few moments of being dead are like, and it's pretty darn disorientating to slip out of your body—or I guess what used to be your body—and to look down on it from a few feet above.

And my vision, which had been getting worse and worse over the years, suddenly became perfect, like when I was a kid. I could see all the wrinkles on my old face, all the nicks and scars on my arms from a lifetime working in the woods. I could hear everything, too: my family screaming and wailing and sobbing while my nitwit son-in-law finally showed some gumption and started pounding on my chest. Nitwit that he is, he was doing it all wrong. It didn't matter, though, since I was already dead.

The confusion didn't last long, and I got used to seeing myself from a few feet away. I seemed to be tethered to my body by some sort of thread I couldn't see. When they took my body to the hospital I got pulled along like I was some sort of helium balloon. Someone declared me dead, and then I floated to the morgue.

I have to admit I looked away during the embalming. I've been through a lot, seen fellows crushed by falling trees and cut up real bad by chainsaws, and none of these ever made me look away. But I never liked needles, and when I saw the size of the needle they were going to stick into a vein in my neck I couldn't look. The thing was as big as a tap. I peeked down later only to

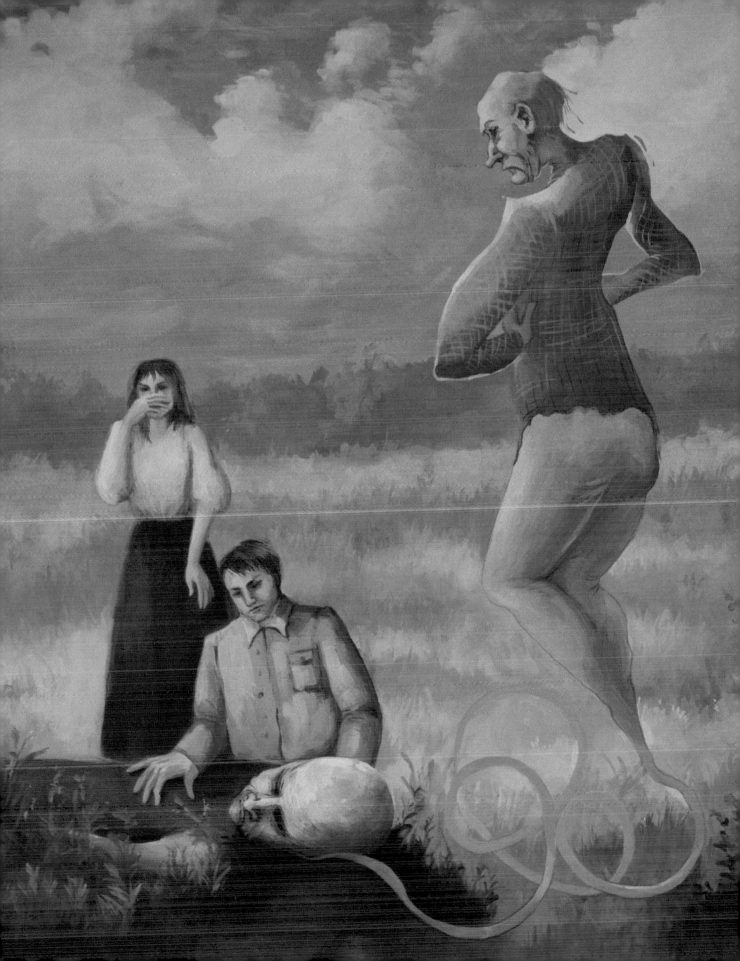

see them jabbing some sort of spike thing into my belly to suck out my innards, and then I had to look away again.

Let's move on.

Being tied to the body by that invisible string wasn't as boring as you'd think. First, it's very restful when no one is around. And second, when people are around, like at the viewing, they say lots of interesting things. It's nice when they tell you good things, like what an upstanding Christian I was, and what a good provider, and how I'd worked so hard to make sure the cut stayed high in the forests. Many women came in sobbing about how I'd saved their men's jobs, and how I'd also saved them, because we all know what a man might do to his woman when he loses his job. That last part's a darn shame, but that's how it is.

There was also a whole other set of interesting comments, these also by people who of course didn't know I could hear them. My nitwit son-in-law and my daughter came in, and they both did some crying, then when they had a moment in the room by themselves, they went back to doing what they always do when they're alone, which is to bicker over nonsense. They stood, hands on the edge of the casket, hissing at each other about who ruined the mood in the car on the ride over.

And then there was my teenaged nephew who brought his girlfriend. When they saw no one was looking they sneaked a deep kiss. A part of me wished I could lift a hand and smack the boy upside the head, and say in a ghostly voice, "Show some respect!" But I had to settle for his mom catching them and saying the same thing, minus the smack.

The funeral was the best part. Who doesn't like to have people get up and fuss over you, and to retell all the great things you did, a good portion of which you did in fact do?

Actually, that's not the best part. The best part is coming soon. The funeral is over, and my body has been buried. The thread that held me to my body has broken, and I'm on my way to meet my Lord and Savior, to meet the Almighty God. My entire life I have strived to live a good life, to make myself worthy of Him, to do nothing that would disappoint Him. I not only accepted Jesus Christ as my personal Savior, but I lived a life to glorify Him.

Traveling to heaven is nothing like I imagined it would be. Well, honestly, I never imagined it at all. I just thought I would die and suddenly be at the Pearly Gates. But that's not how it is. Instead I've been floating heavenward for a few days now. If you ever feel your life is too hectic, here's a good thing: you will catch up on your sleep the first few days after you die.

Finally in the distance I see what I'd been living for my entire life: the Pearly Gates. They're big, and resting on clouds—just like in the sermons—and the gates themselves are made of cloud. Beyond the gates I see a forest even more beautiful than any of those I worked in for so

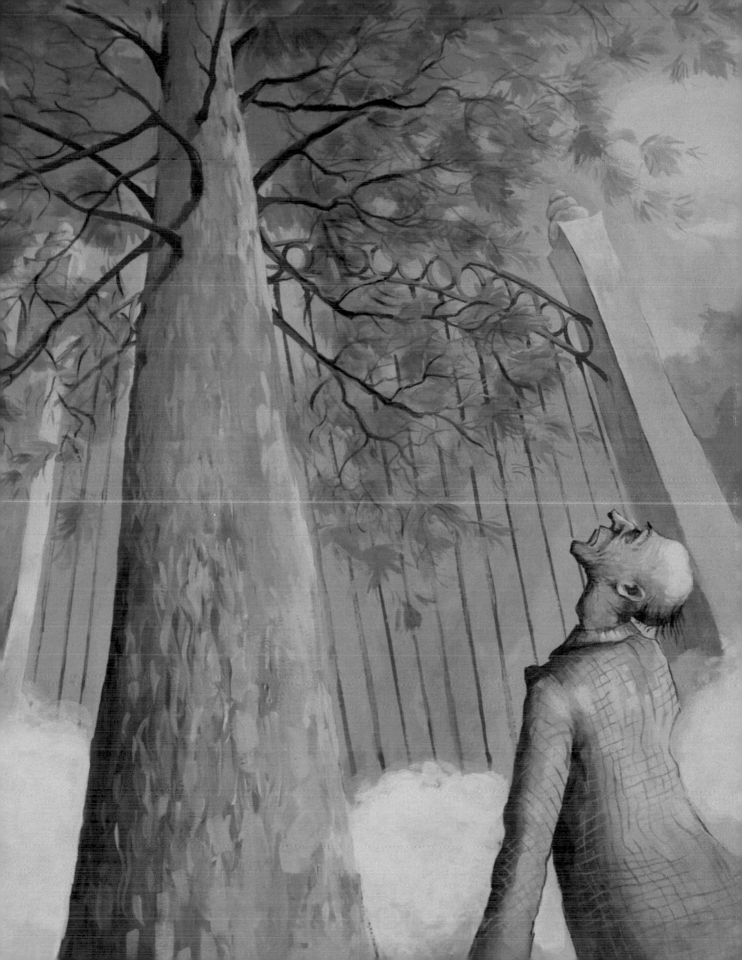

many years. A good crew could take out millions of board feet per year forever. I guess that's why they call it heaven. Outside the gates stands a single giant redwood, the biggest old pumpkin I've ever seen. It's got to be 10,000 board feet if it's a single matchstick. I wonder if they put that here just for me, to honor my work.

I get closer and closer to the Pearly Gates. I don't see St. Peter. I wonder who is going to do the formality of letting me in. Maybe he's on break.

Then I hear him, speaking in a voice I hear inside my head, "Why should I let you into heaven?"

I still don't see him. I wonder if he's using an intercom. I say, "Where are you?"

"I'm standing here in front of you."

"I don't see you."

"Ah," he says, "I didn't think you would."

"So," I say, "My Lord, do I get into heaven now, to be with you forever?"

"I think there may be some slight confusion here."

My mind isn't working well. I don't understand. I say, "You're not saying I . . . But I accepted Jesus Christ as my personal savior. I did right by other people. I harmed no one. I did unto others as I would have them do unto me."

He says, "See, that's the problem . . ."

I plead, "Why won't God take me?"

"Because God isn't a human. God is a tree. So you're not going to heaven. You are going to the other place, where for eternity you will have done unto you as you have done unto others. Chainsaws are not allowed in heaven, but as you'll soon find out, they are quite common in hell."

Troll, Part I

FIRST ILLUSTRATION BY GEOFFREY SMITH
FINAL TWO BY ANITA ZOTKINA

I was just starting to walk under the bridge—a dirty little bridge over a dirty little creek near a dirty little city—when I saw the troll. Of course, I didn't know it was a troll. I'd never seen one before. I just knew it was big and that I was scared.

It said, "Come closer."

I thought about running, and thought about the fact that I'm not so fast as I used to be—as my wittier-than-I sister would have said, I'm "no longer fast, but half-fast"—and I wondered if I was going to die.

The troll said, "Come closer. I'm not going to eat you."

I came closer.

He—the troll had a beard, so I presumed it was a he—said, "Sit."

I sat.

The troll said, "I saw you here before."

"I'm sorry."

"Don't be. I saw you cleaning trash from the creek."

That's when I noticed the troll had been reading.

The troll said, "I wasn't reading just now."

I stared at him, wondered if he could read my mind.

He said, "Don't worry. I can't read your mind."

I frowned.

He opened his mouth wide, and laughed silently. At least I hoped he was laughing. Then he

said, "I can read your face. You looked at the book, then when I said I wasn't reading you looked startled. It's not that hard."

I asked, "What were you doing?" then realized it was an impertinent question.

He thought for a moment. At least I thought he thought a moment. Compared to him I clearly stink at reading faces. Then he said, "I was remembering."

I didn't want to push my luck or my impertinence by asking what he was remembering, so I didn't say anything.

Neither did he.

Finally I screwed up the courage to ask, "What do you want from me?"

Again he opened his mouth wide, did that silent laugh thing.

I started to ask, not defensively, "Why are you . . .?" Then I realized I wasn't sure he was laughing after all.

"Yes, I'm laughing."

We both sat there.

"Because that's a question we've been asking about you."

"Me?"

"All of you. What do you want from us? We can't figure it out."

I didn't know what he was talking about.

He didn't explain.

Partly because I wanted reassurance, and partly because I've never been good at silence, I asked, "So you're really not going to eat me?"

He looked at me, quizzically, I thought, and said, "Do you want me to eat you?"

"God, no!"

He flinched.

I thought three things in rapid succession. The first is that Christianity often vanquishes story-book monsters, so maybe if I said, "I banish you in the name of Jesus Christ our Lord and Savior" he might cower or even flee. The second is that I think that phrase only works if you're a Christian, so I might be out of luck. The third is that maybe I'm not so bad at reading faces after all.

He said, "The stories are wrong about us being afraid of crosses and church bells and the names of the Christian god. We're afraid of Christianity, but not for those reasons."

To be honest I couldn't understand much of what he was saying. Then I remembered how the stories about trolls always portrayed them as kind of stupid. Maybe that was the problem: I couldn't understand him because he wasn't smart enough to talk sense. He was, however, speaking human, English in fact. And I had to admit I didn't know a single word of troll.

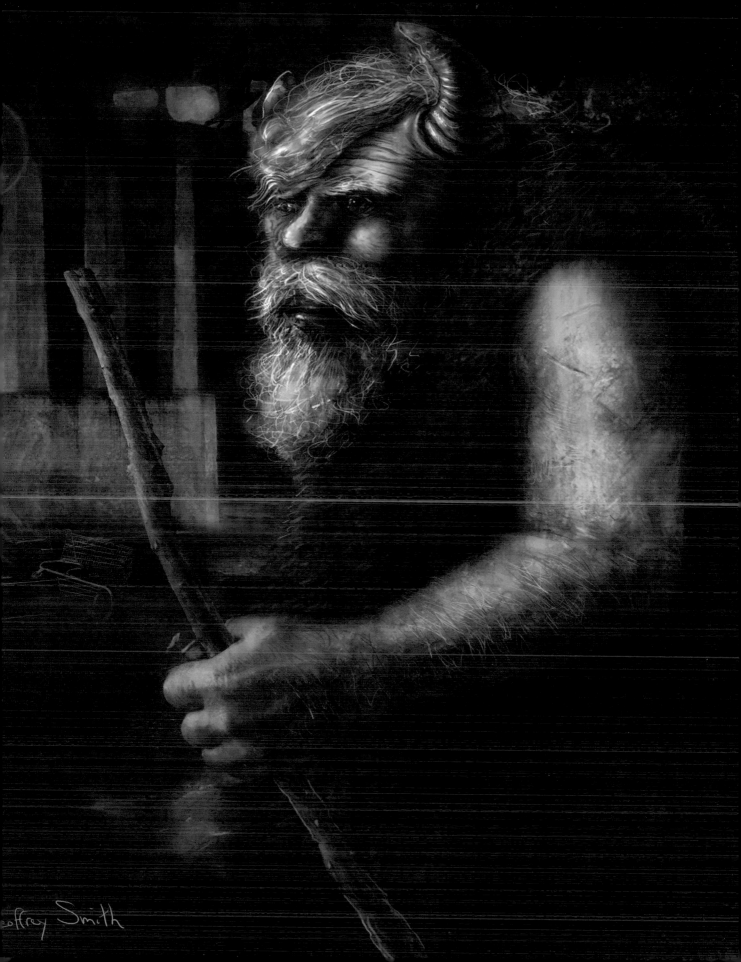

More silence. When I thought I couldn't stand it anymore, he said, "I asked you to sit because I'm lonely."

"Trolls get lonely?"

He looked away, at the creek.

I followed his gaze, saw the handle of a discarded shopping cart rising a few inches above the water. I asked, "Why me? There are lots of humans."

"That's part of the problem, isn't it?"

There he was again, saying stuff I didn't understand.

He said, "You were cleaning up the creek."

"And?"

"The creek is good company, and so is everyone else who lives here."

I interrupted him, "Others live here? They're not going to eat me, are they?"

"Eventually."

I started to stand.

He said, "Sit. They won't eat you now. They eventually eat all of us, when we die."

I sat.

He stared at the creek for a long time. Finally he said, "But your face is close to mine."

Was he going to eat my face? I thought again about standing, thought again about what a slow runner I was. I wished I hadn't sat down. I asked what he meant.

He said, "Humans aren't much good company anymore, but your face looks more like mine than does a chipmunk's or a tree's, or this stream's." He looked at a tree and then the stream, and said, seemingly to the stream, "No offense."

Just my luck, I thought. First, I run into a troll—how much worse luck can I have than that? Whoever heard of someone encountering a troll these days?—and while the good news is that he doesn't want to eat me, the bad news is that he's stone cold stupid and a crazy bugger to boot. I asked, "Why don't you just talk to another troll?"

He nodded, then said, "Exactly."

I didn't say anything.

He read my face, said, "For a human you're not so stupid."

I started to get defensive, until I realized who I was dealing with. Stupid crazy bugger. And big, too.

He said, "Don't get defensive. It's a compliment. You'd rather be not stupid for a human than stupid for one, wouldn't you?"

He had a point, I thought, but I still knew there was an insult in there, if only I could unwrap it.

He didn't say anything.

I gave up on trying to find the insult, and noticed the book was still in his hand. I asked, "What was the book you, er, weren't reading?"

He held up a road atlas.

"You need to go somewhere?"

"Exactly. You keep making my point."

I beamed. I understood his compliment. Or at least I thought I did.

He said, "That's why I asked you to sit."

Now I was back to where we started, not understanding a word this stupid troll was saying.

He asked, "Would you rather I start at the beginning, or at the present?"

The present seemed like it would make for a shorter version of the story, so that's what I answered.

He said, "Good friends are here, but I miss . . ." and then he said a word that sounded like it must be in troll. He explained, "That means my girlfriend except without the my since it doesn't imply ownership. And it doesn't really mean girlfriend because, well, we get along."

I tried again to get defensive, but again I failed. So I just sat there.

He said, "I miss other trolls besides her, too."

I nodded. Once I made allowances for him not being so smart and also kind of crazy, he wasn't such a bad guy.

He said, "There used to be many more of us. And we didn't used to live under bridges. We lived under fallen trees near streams. But how many of those do you see anymore? We—those of us still around—make do. And don't get me wrong, I love this stream. But this stream is just making do, too."

He began to sing. I didn't understand the words, of course. Honestly, for the most part I couldn't even tell one word from another. And at first the tune sounded jarring, like monkeys or coyotes or a bunch of birds, but soon I got used to it, and then with no discernible transition I ceased to be aware of it entirely. Words and tune enfolded me until they became the air I breathed, the sights and sounds and smells I took in.

And then the strangest thing happened. No longer was I sitting under this concrete bridge, listening to cars whizzing overhead. No longer was the stream dirty. The shopping cart was gone, as were the brownish bubbles from God-knows-where and the oily-sheen that came with them. The stream was . . . young. It was healthy. It was alive. I don't know how else to describe it.

And there were trees everywhere, tall, round trees whose branches intertwined and broke the sunlight into slanted rays. Muted sunlight textured the forest's browns and greens and yellows.

More birds than I had ever imagined—orange and brown and white and red and blue—flitted from branch to branch, gossiping and chattering and preening and loving. The ground was covered with the parents of these trees, and their parents, too, slowly returning to where they came from, to the soil, to the earth.

I saw mammals, too, voles and shrews and bears and humans.

And when I looked closer I saw trolls. I saw them sitting—as this troll had said—beneath downed trees, by this same stream, this stream so full of fish I could see fins above the water, and I could see that the trolls, too, like the birds, like all these others, were gossiping and chattering and preening and loving.

The song filled me with joy and a longing so deep and profound that I almost wished the song had never begun. Is it better to simply feel empty, or to know what you have lost and to know the source of this emptiness, in full knowledge that what has been lost can never in your lifetime be returned to you? I did not know in this moment whether to love or hate this troll, or to simply feel his pain and my own.

The song continued, for how long I cannot say, and when it ended I learned my cheeks were wet.

I said, "I am sorry."

He said, "That's why I asked you to come closer. That's why I asked you to come closer. You don't hate me for showing you that. Or at least you don't only hate me. And you don't lie to me or to yourself by saying it was never like that. You were cleaning the stream. That's why I asked you."

"But what can I do? I can't bring back the stream. Not by myself."

"You can help me find . . ."

"Your girlfriend?"

"To use your language, yes."

"Where is she?"

"That's why I have the atlas."

"Why can't you go to her?" I asked.

"I have a hard enough time avoiding humans by staying under this bridge. I'm nearly discovered almost every day. So can you imagine what would happen if I tried to travel? The fact that we can't travel is one reason there are so few of us now. If I were caught—and if they were able to take me alive—I'd be put in prison—"

"For what?" I interjected.

"For not being human. It's called a zoo. A research lab. Or they'd shoot me in the name of

science. 'Collect' me, dissect me, categorize me. And it would be a disaster for the few remaining trolls. The roving eye of science would fall on us and they'd know we're real and we'd be doomed. They'd kill or capture us. They'd manage us. They'd manage us to death."

I wanted to let him know I felt his pain. I said, "That would be awful, to be managed."

He looked at me quizzically. "You think you're not?"

There he went again with the stuff I didn't understand.

He said, "And you know they'd vivisect us."

More silence. I was afraid to say it would be horrible to be vivisected in case he responded by suggesting it's already happening.

"You see why I can't go, right?" he said.

"So what do you want me to do?" I asked.

He told me. He told me where to find her and how to let her know I was on her side. He told me what to do after that.

We talked through the afternoon. I asked him to sing me another song. He did. It was as full of life and longing as his earlier song had been.

Finally, it was time for me to go.

But before I left I had to ask, "So, what do you eat?"

The troll threw back his head and laughed that silent laugh. He laughed and laughed. When he stopped he looked at me a moment, then said, "Come closer."

I did.

He smiled.

Funny, I thought, I never before noticed his teeth are so sharp.

To be continued . . .

Angel

ILLUSTRATIONS BY KYLE DANLEY

I'm dreaming. I'm flying over a beautiful valley. Every sensation is intensified so I feel the colors of the forest beneath me and see the sounds of the wind rushing past my ears. I dive and swoop and climb as heart-stoppingly as a swallow.

And then I realize I'm not alone. I'm flying with someone. I look in his face, into his dreamy eyes. He matches me dive for dive, swoop for swoop, climb for climb. And each time we dive or swoop or climb he gets a tiny bit closer. And then closer, and then closer.

Did I mention we aren't wearing any clothes?

And then . . .

The fucking alarm clock goes off. Half awake, I say, "God damn it."

My boss says, "I heard that."

No, my boss isn't in my bed. But he may as well be. He hears everything.

I hit the snooze button and think, "One more moment, Mr. Sandman. I beg you."

Mr. Sandman is evidently in a giving mood, because he turns on his magic beam and brings me that same dream. Mr. Dreamy Eyes flies closer, and closer. We kiss, softly, gently. But I'm so hungry for closeness that I can't bear even this slight distance, and I pull him closer. Our bodies entangle. A part of me, knowing the alarm could go off any moment, thinks, "Hurry, hurry!" I wrap my arms and legs around him. I wrap my wings around him.

Big mistake. Our wings tangle, and we plummet. I can feel the ground getting closer and closer and see the wind screaming past my ears. "Just my luck," I think. I wonder if that's the last thing I'll ever think. Then I wonder if that's the last thing I'll ever wonder.

The alarm clock sounds again.

I struggle to catch my breath. I'm sweaty.

I fly as fast as I can to the Center. I get there right on time, clock in, and get in line with the other angels to receive the week's assignment. Like always, the line melts away in front of me.

I smile and motion to other angels that I'm happy to wait in line with them, but as usual they give me wan smiles and urge me forward.

What am I supposed to do? We could all stand there all day. That's not helpful to anyone. So I walk to the front of the line.

I don't understand it. I don't stink. I'm not unpleasant. But I feel like the other angels resent me. They chat with each other, but never with me. It's like I'm the plague. They don't come within five feet of me. And no one will tell me why.

There are others they treat the same way. I've never spoken to the other pariahs, mainly because they kind of scare me. It's nothing physical: some are bigger than I, and some are smaller. Some are male; some are female. It's not even that they look mean. Some do, some don't. But I never can get up the nerve to speak to any of them. There's something off about them, something vaguely terrifying. They don't seem to talk to each other, either. And all of them get to go to the front of their lines too.

So I walk past the angels to the window to pick up my assignment. Even the angel who hands out assignments never wants to talk to me. She's perfectly pleasant, but closed off. I ask her how she's been for the past week.

"Fine."

I ask if she did anything exciting.

"Not really." She smiles to let me know I shouldn't take her terseness personally, but her smile is as watery as everyone else's.

Usually I just move on, but today I want to make her talk to me. I don't care about what. So I ask, "How are the assignments made? Who makes them?"

She does a double take, then says, "Huh?" Once again she smiles to take the edge off.

"How is it decided who has me for an angel, and who has . . ." I make a sweeping gesture toward the other angels, waiting at a distance for me to get my assignment and go.

"I dunno," says the angel behind the desk. She's got fidgety hands with chubby fingers.

I shake my head. The angel's hands get even more fidgety. Before I move on, I glance at my assignment. It's someone in New York City. I hate that city. I murmur, "God damn it."

I hear my boss say, "I heard that."

◑◑

I take off to find my new assignee. As I get closer to New York City, I look down, and that line from "Eleanor Rigby" about lonely people comes to me, as it often does when I fly above a city.

I was assigned to one of The Beatles once. It was John.

I'm not meaning to name drop. Given that we've been doing this since what seems like the beginning of time, most of us end up snagging a famous person once in a while. We've got to, right? It's the luck of the draw. If I wanted to go a different rock-and-roll direction with this, I could without lying point out that I was present when Jesus had his moment of doubt and pain. I was also assigned to someone named Georg von Bismarck, who "held a general's rank" during the Blitzkrieg's reign. I was not, however, present when Anastasia screamed in vain. Someone else was assigned to her. That week I was assigned to take care of a low-level mobster in Chicago.

Today I'm assigned to an expert in facilitating world trade. You could say he's just another mobster, and I would have to agree with you. Only the mobster in Chicago used brass knuckles and handguns to enforce his profit-making schemes. The world trade mobsters use entire governments.

Three guardian angels are normally assigned to protect a person for a week at a time. The angels split the coverage, with each taking one shift a day. Sometimes the off-duty angels hang out together. Not with me, though. I used to ask why, but they always had excuses. Now I just briskly inquire how they want to divvy up the shifts, and they politely defer back to me.

Don't they understand I don't want special treatment?

Don't they understand I just want to be one of them?

I am desperately lonely. I feel a gnawing emptiness in my belly, a hollow cold that radiates downward to my pelvis and up into my heart and shoulders and into the bones of my face and behind my eyes. I don't know what to do.

There's a misconception about angels that we're all one big happy family. Another is that we don't feel.

A few more misconceptions. Angels can't stop bullets, deflect oncoming trains, prevent earthquakes, hold back fires (or failing that, breathe oxygen into soot-filled and failing lungs). Nope. Angels are advisors. What you do with our advice is up to you.

I look again at today's assignment, check the address. I'm getting close. Dawn is hours away. There aren't a lot of people on the streets. I glide down till I'm only a few feet above their heads. They don't see me: no humans can see me, and they can only hear me when I address them directly.

It's warm, the sort of early September pre-dawn that reminds you it's still summer.

I see an older woman about to jaywalk, and even though she isn't my assignment for the

week, I feel the need to advise her not to cross here. She listens, and follows the sidewalk to the corner. I think about staying with her to remind her to look both ways, but also decide that would be overkill; she's not six. I fly away. At the end of the block I look over my shoulder, just in time to see a car run a red light and knock her tail over teakettle.

I say, "God damn it!"

My boss says, "I heard that."

<p style="text-align:center">oo</p>

I get to the assignment. The other angels are waiting. They greet me respectfully, but with slight trepidation.

I ask them what's wrong.

"Nothing," says the first.

"Nothing at all," says the second.

I look heavenward, then shrug and ask, "Why don't I take the first shift?"

They both nod blankly.

I feel like I could make any suggestion and their response would be to nod blankly.

Usually I leave it at that, but today I decide to test them. "Hey, wanna go fly above the river a while?" Let's see them nod blankly to that one.

They don't nod. They freeze. You know the phrase, "like a deer in the headlights"? It's not just deer. I've seen plenty of humans freeze that way, eyes wide, bodies and minds immobile. I see it almost every week. I see it often in their last moments. It's a frank incomprehension that no matter what they understand intellectually about life and death, their own life—which they took for granted would last forever—will in fact end quite soon. I don't mind so much when I see this in humans—like I said, I see it all the time, like on the woman's face this morning just before she got hit by the car—but I hate seeing it on the faces of angels.

Why would angels go wide-eyed like that? They do, whenever I speak to them, even when I ask a simple question like, "Can you at least tell me why not?"

I've asked that question thousands of times of thousands of angels, and they've always responded the same way: with a show of discomfort, trepidation, or outright fear. And they never answer my question.

But this time, as I turn away, one of the angels clears her throat.

I turn back.

She says, "You're not like us."

The other angel almost imperceptibly shakes his head at the first angel, communicating to her that she has said too much.

I ask, "What do you mean? How am I different?"

Wide eyes yet again. No sound. Then a stammer, "You just are. I can't say. Ask the boss."

"Ask the boss" is a common phrase among angels that means "You'll have to figure this out for yourself." Everyone knows that when we ask the boss a question, the boss never answers.

○○

I take first shift, which starts while the guy's still asleep. I find it important to pay attention to a person's dreams, because they give insight into the person's concerns and desires, which can then influence the advice we give when questions arise during the day.

He's dreaming about dying, which is more common than one might think. It often means the person is struggling with a transition, an end to a job or relationship or addiction or habit. I'm wondering if this particular transition has to do with his family. His wife is next to him in bed, and his two children are asleep in their own rooms in this luxury condo. In his dream a building collapses around him. I don't even know the guy yet, but it's clear that whatever transition he's facing is causing him to feel like his entire world is crashing down around him. This tells me he craves structure and stability. He has another dream, this one of being surrounded by fire. I'm certain it means he feels as though the pending transition is burning him alive. It's consuming him. I'll advise him to relax a little, take things a little slower. Then the transition won't be so terrifying.

He wakes before his alarm, well before dawn. He opens his eyes and stares into darkness. Right away he fixates on his problems. I find I read his dreams correctly, save for one detail: his concern isn't his family, but rather his job. He hates it. He can't bear it even one more day. It's Monday, and he's calling in sick, even though he isn't really sick at all. He's sick of work, he thinks, and that's good enough for him. Actually, he wants to go in, tell them to all go to hell (maybe that was the meaning of flames in his dream! I'm pretty good at this!) and never go back.

I look at his wife. I think about his children. I reflect on his dreams and their obvious meanings, especially his need for structure, his fear of structures collapsing. So I start to speak to him, in a voice only he can hear, a voice that sounds to him like the voice of reasonableness. I say, "You can stick it out a bit longer."

He says, "No, I can't."

"Just until you get another job."

"I can't."

"Two weeks notice, then. You owe them that." I have no idea if he does, but sometimes you have to go with your gut.

You might ask what I'm doing trying to talk someone out of quitting his job, but this condo is spendy, and I don't want his family to be put into straitened conditions that might lead to an unsafe situation. So I'm giving generic advice influenced by my interpretation of his dream.

He says, "I think I can do two weeks. But I can't face work today. I'll give my notice tomorrow."

I've pushed as far as I can. We have a plan.

I feel I've accomplished something important, something useful. In times like this, I love my work.

<center>∞</center>

The rest of the day is both easy and dull. He goes back to sleep, and later his wife wakes in a panic that he's late, but he tells her of his decision. She's not surprised. She knows he hates his work. She's happy. She tries to convince him to call in today and never go back. He has weeks of sick leave coming to him.

It takes some light arguing on my part to get him to stay strong in his conviction to do the right thing and go in tomorrow to give them two more weeks.

She's OK with that. They make love before the children arise. I figure they've made love plenty of times before, so I only keep a vague watch to make sure no one falls out of bed and hits a head. Then they start their day.

I feel like the crisis this morning was the reason I was sent, so I have the luxury to not pay quite such close attention to the man and his family for the rest of my shift. I start thinking about what that angel said to me: "You're not like us." Maybe she said that because I'm so good at reading these crises and telling people what to do. Maybe I'm not like the other angels because I'm something special.

I've noticed over the millennia that I'm often assigned to watch over people at crisis times in their lives. I'm there when young people are deciding whether or not to join the military, and I'm there when soldiers go into battle. I'm there when junkies try to decide whether they should quit suddenly or taper off. And I'm there when people with cancer are deciding what sort of treatment they should get, or to get no treatment at all. When I'm on a job, I often get a feeling like the one I had today: that my reason for being here is through.

Because of that feeling—and because I've never been wrong on that feeling—when my shift is over I fly back to the Center to tell them the crisis has passed, and the person is no longer

in need of my services. Then the one who hands out assignments cross-checks with a list of names—I'm guessing these are other people whose crises have gone by—and nods and says, "Yes, your job is done. No more need of an angel."

This moment always makes me proud.

Maybe the reason the other angels don't talk with me is that they're uncomfortable with me being a sort of crisis specialist. They do the line work, and I'm the emergency angel. Maybe that's my secret title, "The Angel of Emergency." I like it. I'll bet that's true of all of the other pariah angels too. I'll bet we're all elite. And everyone else is jealous.

∞

I remember something else the angel said, too: "Ask the boss."

That's exactly what I'm going to do.

∞

I fly back to where the boss is. I'm not going to try to explain to you where it is, or the logistics of how I get there. Let's just say it involves a wormhole, a belt, three stars, a sharp left turn, and either six or seven dimensions, I can never remember.

I show up outside the boss's administration building. I walk to the receptionist's desk and ask to see the boss.

The receptionist doesn't even ask if I have an appointment. He says he's very sorry, but I can't.

I don't know why I even asked. Nobody ever sees the boss.

"God damn it," I say.

The boss says, "I heard that."

I say to the voice, "I want to see you."

I receive no indication of whether or not he heard that.

I'm about to turn back to the door when the receptionist says, "But I'm sure you can see the boss's son."

"J.C.?"

He checks J.C.'s schedule, then announces my name over the intercom and escorts me to his office.

∞

Jesus Christ is sitting behind a desk. When I enter he leans back slightly in his chair, and

gives me that wan expression I know so well. He recovers quickly, though, or at least tries to, and attempts a warmer smile. He says, "It's been a long time . . ."

"Almost two thousand years," I say. "You haven't aged a day."

He smiles again, or at least tries to. Then he leans forward and says, "Before we get to your reason for being here, I want you to know that I've forgiven you."

I hesitate, then ask, "For what?"

A confused look passes quickly over his face—it's a good thing this guy isn't a poker player—before he masks it with another smile. "For everything. That's what I do," he says.

I hesitate again, then finally say, "I thought it might have been about the advice I gave you . . ."

"To allow myself to be arrested, then throw myself on Pontius Pilate's mercy?" He pauses, then continues, "That turned out how it was supposed to in the end. Not that it wasn't excruciating in the meantime. Honestly, I resented you for a while, but then remembered that my job is to forgive everyone for everything. And I'm okay now, so it's all good." Another pause. "Besides, you were just doing your job. It's nothing personal."

I pride myself on my professionalism. "It never is, is it?" I say.

I look around the room. If you've ever wondered What Would Jesus Do when it comes to decorating his work space, I can tell you his tastes run more to twenty-first-century office than they do to sixteenth-century cathedral.

He points to a comfortable chair—at least it's not a couch—and says, "Sit, please."

I do.

He asks why I've come to him.

I tell him I'm having some troubles, and was wondering if he could help me.

He releases his breath as though he'd been holding it. He smiles. "Oh, I thought you came to . . . So this is more of a personal visit, and not a professional one?"

"Yes, I suppose it is."

He gets up, walks around the desk, sits in another comfortable chair near to me, and says, "What is troubling you?"

When he asks it like this, all straightforward and personal, suddenly I feel silly. I'm here speaking with Jesus because another angel said I'm different? What am I, a child going to the principal to tattle on another student?

"Don't be shy," he says. "You have your role, and I have mine. Mine is to forgive, and to listen to people's troubles."

So I tell him of my loneliness, and of how the other angels melt away before me, of how they avoid speaking with me, of how they seem to be afraid of me, and of how I made this trip to his

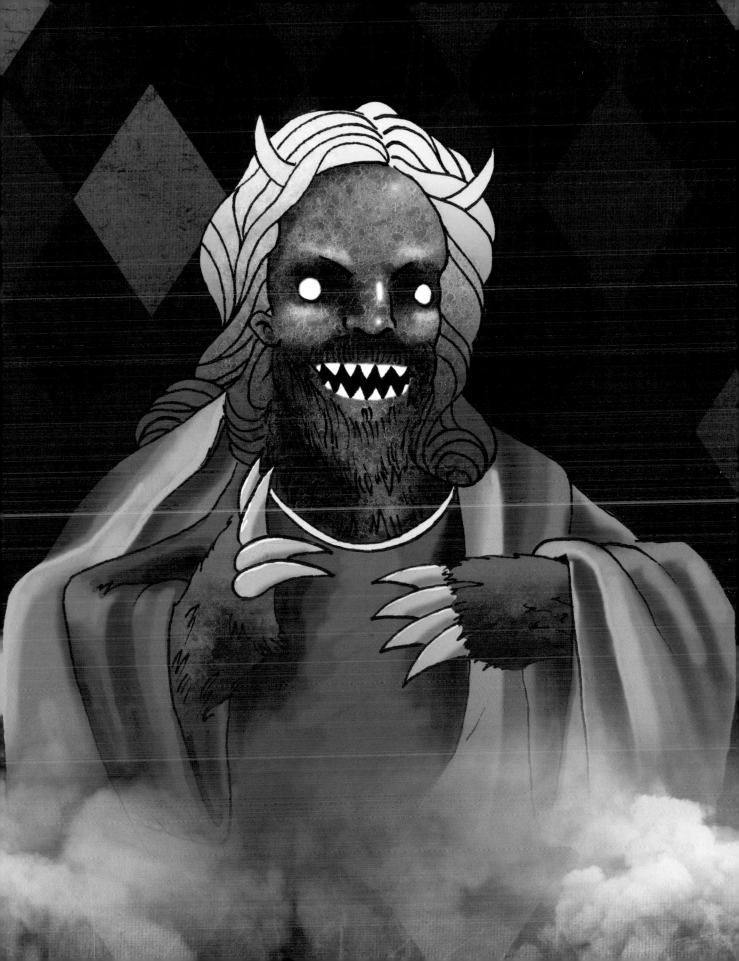

office because of what the other angel said. As I'm speaking, he listens with such attention that I feel I'm the only being in the universe.

Except when he looks over my shoulder to where his receptionist has opened the door, and then stage whispers, "Hold my incoming prayers a few more minutes."

When I finish, he is silent for a long time. At last he says, "How did it feel to tell me that?"

I just look at him.

"It sounds very difficult," he says.

Another long silence.

"I guess turning the other cheek won't work . . ."

"Nobody ever touches my cheek."

"Or rendering unto Caesar . . ."

A very uncomfortable silence.

"I, er, I, well . . . Honestly, I'm more of a listen-to-your-troubles kind of guy, and less of a solution kind of guy," he says.

That does sound about right, doesn't it?

Suddenly he stands, gives me a politely apologetic look, and says, "I wish we could talk longer, but prayers are waiting. I don't know why so many people want me to get involved in athletics. Why would I care who wins the American League pennant?"

We exchange a pro forma hug—which I can tell he's very glad to quit early—and he sends me on my way.

☉ ☉

I'm walking past the receptionist, now standing in front of his desk, and he lightly taps my shoulder. I'm so unused to being touched that I do a double-take.

He looks around, then hands me a slip of paper.

I look at it. I see directions.

The receptionist looks into my eyes and says, "I overheard some of what you said. These folks may be able to help."

☉ ☉

I leave the building and begin following the directions. This time the route involves a deep forest with a thick canopy far up in the sky, a winding path, and several streams.

I arrive at a natural opening in the understory. The directions tell me to enter. I do.

And that's when I see the spiders. Three of them. Orb weavers. Huge. Far bigger than I am.

They're releasing their silk, weaving it with their long legs, and cutting and anchoring the strands. The web stretches behind them, far into the forest; farther than I can see.

The spiders scare me. I wonder if the receptionist sent me here to die. Maybe death is the solution to loneliness.

It seems the spiders can get in my mind, just as I can get in the minds of humans. One of the spiders says, "Of course we're going to kill you."

The second says, "But we won't."

The third says, "Not directly."

They laugh: a chittering, clacking sound.

They continue to release their silk, weave it, cut and anchor it.

"You've nothing to fear, dearie," the first one says.

"Nothing at all," says the second one.

The third one says, "Nothing. Exactly."

More of the chittering, clacking sound. More of the releasing, weaving, anchoring.

"Come closer."

"We won't eat you."

"Not at all."

Their legs are constantly moving.

Their movements are beautiful, mesmerizing. I feel as captivated by the beauty of their dance as I would be held captive by their silk. I come closer. And closer.

I see that hanging from the strands of the web are silk-wrapped bodies. Thousands of them. Millions of them. Uncountable numbers of them. Every size and shape imaginable, in every possible state of decay. There are dead dogs and cats and trees and starfish and humans. Some are mere tatters of silk barely covering skeletons of wood or bone or chitin. I see that the ground itself is made of bodies, bigger giving way to smaller giving way to smaller giving way to soil.

And that's when I see an angel.

Dead. Decaying. Wrapped in silk. I look at the spiders in horror.

"Oh, don't look at us that way," says the first spider.

"Everybody dies," says the second.

"You know that," says the third.

"Angels?" I say.

"You must have heard of some angels who've died," says the first.

"How would she? None of the other angels will talk to her," says the second.

"Well, angels die," says the third.

"Guardian angels die."

"Other angels die."

"You will die."

Then I see that some of the silken bundles hanging from the web are not decaying, but instead growing. I see a small hole appear in one close to me. The hole grows larger and larger, until I see a snout poke through, then a brown head. The cocoon bursts and a lizard falls to the ground, shakes himself, takes a quick drink from one of the streams, and scampers into the forest.

Then another cocoon bursts, releasing a small shark who flops this way and that till she makes her way to one of the streams. She swims downstream. Creature after creature emerges from its cocoon, drinks from or dives into a stream, and enters the larger world.

"What is this?" I ask.

"And you know that J.C. will die, do you not?" says the first, ignoring my question.

"He already did once, but will again," says the second.

"He will die and come back, die and come back, and eventually die and not come back," says the third.

"And your boss will die, too."

"And come back, and die, and come back."

"And eventually not come back. And then he will be no more."

"My boss? He's everyone's boss," I say.

The spiders laugh and laugh and laugh. The entire web shimmers with their chittering, clacking laughter.

And that's when one of them bites me.

She moves so fast I don't see her. I don't even feel her. I'm standing, and then I'm on the ground, with no discernible transition.

◑◐

I can't move. I wonder, "Is this what it's like to die?" I wonder if this is the last thing I will ever wonder.

I cannot keep my eyes open. I struggle, and I struggle, and I struggle, and then I give in to it, and close my eyes.

◑◐

I open my eyes. Maybe I'm not dead. Or maybe this is what it's like to be dead. Having never before been dead, how would I know?

The spiders are gone. So is their web. The opening in the understory remains, but now in the middle stand three giant trees. Their skin—wait, I mean bark: did I just say skin?—is reddish-brown, with light-green lichen growing on it. Mushrooms grow along the ground.

I can see into the soil, the soil made up of dead bodies fallen from the web, and I follow the tree underground. The trunk splits into roots, who split into roots, who split into roots, who split into roots, who entangle with the roots of the two other trees, who entangle with the roots of other trees and shrubs and grasses. And intermixing with all of these are the long, filamented bodies of fungi, of whom the mushrooms are merely the tiniest fragments poking above the ground. I try to see where root tip ends and fungus filament begins, but I cannot. And among and around them all I see insects and arthropods and worms. And then I see entire worlds of bacteria and viruses and protozoa. I see that the soil is made up of their bodies, too.

I see that the web spun by the spiders has not disappeared, but merely moved underground. The web is everywhere. It cannot be avoided.

●●

I close my eyes, and when I open them again I see above me three giant bats. They spread their wings, wings so large they together cover the sky, wings so transparent and thin that I can see right through them, past the skin and the delicate hairs that detect the slightest shift in winds, past the nerves, past the veins and arteries and the web of capillaries, filled with living blood cells, carrying also the bodies of dead blood cells, each living and each dead cell a world of itself, each cell connected to other cells.

I close my eyes.

●●

I open my eyes. The spiders are back. So is their web. They carry on as though they never left. Maybe they never did.

The first spider asks, "Have you ever seen a fly in a spider's web, and wondered why it chose to go left into the web, instead of right to continue life?"

The second spider asks, "Was that just bad luck on the fly's part, and good luck on the spider's?"

The third spider asks, "Or did the fly receive advice?"

"How would I know?" I think.

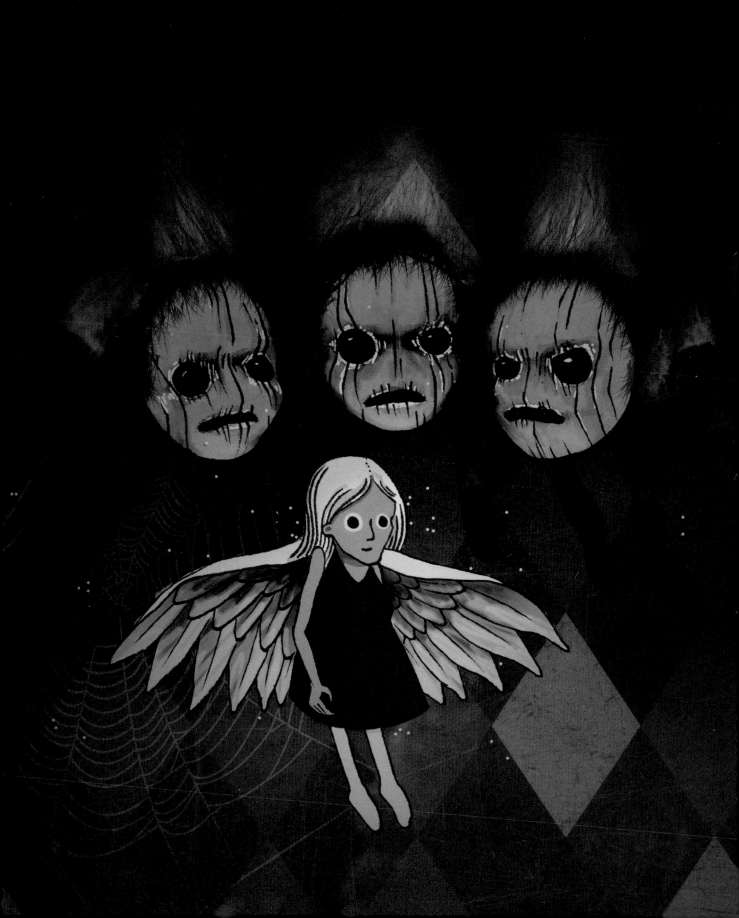

The first spider smiles. "Why would someone cross a street at the corner instead of in the middle?"

"Because it's safer," I say.

"And why did Abraham Lincoln's bodyguard at the theater choose that particular time to step away for a drink? Bad luck?" The second spider asks.

"No, bad advice from an angel," I say.

The spiders laugh. The third says, "Or perhaps good advice. The right advice. Like the advice you gave the woman crossing the street. Like the advice you gave J.C."

"What are you telling me?"

"Do you remember that German general you advised?" asks the first spider.

"I was thinking of him this morning."

"Do you know what ever happened to him?" asks the second.

"I didn't pay attention," I answer.

"He was blown up a few weeks after you were with him. His new driver accidentally drove into a minefield," says the third.

The first spider asks, "Do you remember the last advice you gave him?"

I respond, "If I recall, he was thinking about bringing on a new assistant. I suggested he do it."

The second spider says, "Yes, very good."

The third spider asks: "And what was this new assistant's primary duty?"

"I think he was supposed to be a driv— Wait! I don't understand!"

The first spider says, "It may help if we ask about some of your other assignments."

The second spider asks, "Do you mind?"

I hesitate.

The third spider says, "It will help answer the question that caused you to come to us."

I nod.

"Do you remember a young woman from South Dakota you advised during the 1918 flu epidemic?" asks the first spider.

"I do! I remember her well because she was quite the heroine. She was nineteen or twenty years old. One of the nearest neighbors to her family's farm got sick, then that whole family came down with it. No one could take care of them, so she volunteered."

"Do you remember the advice you gave her?" asks the second spider.

"Very much so. I was there when she made that decision to help the neighbors. There wasn't any question she was going to do it, but she still got scared, as anyone would in the face of death. I helped her to be strong in her decision. One of my proudest moments, I think. Remarkable

young woman. I often wondered what ever happened to her. She had great things ahead of her."

"She caught the flu and died," says the third spider.

"I don't . . ."

"Or there was a nice teen-aged boy who gave his mother a birthday gift," says the first spider.

"A hand-made coupon book with tabs she could tear off to redeem for chores," says the second.

I say, "I vaguely remember. I think I suggested he add a coupon for cleaning out the eaves at their house."

The third spider adds, "Yes, you did, and his mother cashed in that coupon a couple of months later. The boy fell off the ladder and died."

"God damn it."

I wait for the response that never comes.

The first spider says, "There was another nice young boy you advised. He had very low self-esteem."

"You convinced him to go out for football, told him that no one would laugh at him," says the second.

I exclaim, "Don't tell me people laughed at him and he killed himself."

The third spider responds, "No, he died of complications from heatstroke on the third day of practice."

The first spider says, "Or there was a man with faulty wiring in his house."

"Oh, no!" I respond.

The second spider says, "You convinced him to fix it himself."

I shake my head. "I think I see where this is going. He burned himself up, right?"

The third spider answers, "No. He was outside working on it, and his neighbor's dog got loose and bit him in the face. He died of a heart attack on the way to the hospital."

"And there was a woman you convinced to fly to visit her mother. The plane crashed," says the first spider.

The second spider adds, "The man you convinced to do his dishes that night instead of the next morning, who dropped a glass full of water, then slipped and fell and cracked open his head on the kitchen floor."

The third spider also adds, "The woman you convinced to take walks for her health, who was then struck and killed by a runaway car driven by a man you'd suggested was healthy enough to drive who had a stroke behind the wheel. Both died."

"I am a completely incompetent guardian angel."

The first spider releases some silk. "On the contrary! You are extremely competent."

The second spider spins the silk into a web. "You are just not a guardian angel."

The third spider ties off the ends of the silk. "You are an angel of death."

"You are our assistant," says the first spider.

"As are guardian angels," adds the second.

The third spider ties another end. "They help keep them alive for the length of their strand, and when it is time for their strand to be cut . . ."

"You turn to me."

"Or to other angels of death," says the first spider.

"The other pariahs," says the second.

"All of whom act differently," says the third.

The first spider says, "Some are like you, giving advice that leads to death."

"Some are long-term planners, planting disease decades before the strand is to be cut," says the second.

"And some just go in with the scythe and lay waste," says the third.

"No wonder the other angels hate me."

The first spider says, softly, "Oh, they don't hate you, dear one."

The second spider says, "They're afraid of you."

The third spider says, "If you ask them to fly with you over a river, they fear they're fated to crash and drown. Would you spend time with an angel of death?"

I say, "At this point I would spend time with anyone who would have me."

The three spiders chatter in their spider language for a few moments, then the first spider speaks: "You are already perfect as you are, but if this is what you want, we may be able to help you."

The second spider asks, "Why do you think the receptionist helped you find us?"

The third adds, "He doesn't give directions to just anyone."

"Do you think he would spend time with me?"

The first releases silk and says, "You won't know unless you try."

"But won't he be afraid of me?"

The second spins it out and says, "We will tell him he has plenty of thread left. We don't normally do that—rarely does anyone know the day and hour of death—but we can make an exception."

The third ties off the silk. "He'll have no reason to be afraid of you. The rest will be up to you."

"You would do that for me?"

"Why not? We're not cruel," says the first.

"Not in the slightest," adds the second.

The third says, "And it's the least we can do for you, after all the hundreds of thousands you've killed for us."

I say, slowly, "I have killed for you."

"That is what you do," says the first spider.

"Everyone dies," says the second. "Someone has to help them."

The third spider says, "Without death there is no web, just as without life there is no web."

"This is true of everyone."

"From bears to barracudas."

"From rocks to rivers."

I say again, still slowly, "I kill. That is what I do." Then suddenly I am struck with horror. I ask, "What about the man I just spoke with?"

"Tomorrow he will go to work, as you suggested."

"And the building, a center for world trade, will burn, and it will collapse."

"And he will die."

I say, "I need to get out of here. I need to change his mind."

"His thread must be cut," says the first spider.

"It is his time," says the second.

And that's when the third spider bites me.

Again.

○○

I'm dreaming I'm in a forest, flying under the canopy in a beautiful opening in the understory. I see a web spreading in all directions, beneath me, above me, around me, in me. I dive and swoop, and my heart stops from the sheer joy of it.

In this dream I am not alone. The spiders are below me, releasing, spinning, tying off.

And flying next to me is the receptionist.

He's looking into my eyes again, and this time I can see that his eyes are as dreamy as any I could ever hope to see. We aren't naked, though, like with the angel in the previous dream. No, this dream might become reality, so I am shy, and we are both clothed. But not so much that I can't see his soft and glorious skin.

I dream, and then I dream, and then I dream, and then I slowly start to awaken, in a process

as delicious as the dream itself. I am warm and I am comfortable. My arms and legs and wings and head are all impossibly heavy. I am lying on the ground. The spiders move before me in their dance so beautiful I feel as though my heart will break into a thousand pieces.

Still I am not awake. I am drifting ever so slowly toward consciousness.

In my dream I hear the first spider say, "My sisters, what shall we do with this angel?"

"Now that she knows, she may become self-conscious, and give bad advice," says the second.

"Advice that doesn't kill," says the third.

The first says, "Let's just do what we do for the babies."

"Have her drink from one of these streams."

"And like the others she'll forget."

And suddenly I am thirsty. I have never been so thirsty in my life. In my dream a spider comes to me carrying a silken cup, and from this I drink, and I drink, and I drink.

○○

I awaken. I stand. I am in a natural opening in the understory of a deep forest. I see a thick canopy far up in the sky. In front of me are three giant orb weavers, constantly releasing silk, weaving it, tying it. They are creating a web that seems as big as the entire universe. Hanging from this web are millions upon millions of silken bundles. Some are decaying, some are growing. Some are bursting with new life.

Somehow I am not afraid.

Their movements are beautiful, mesmerizing. I feel captivated by the beauty of their dance. I come closer. And closer.

The first spider says, "We are so glad you have come to visit us, dear one."

"I remember coming here, but I don't remember why," I say.

"It must be because we have a task for you, a task that only you can do," says the second spider.

I feel honored, and needed. I don't remember the last time I felt needed by anyone.

"Could you please deliver a message to the receptionist who sent you here?" asks the third spider.

I do remember a receptionist. I seem to remember liking him.

"Please tell him his thread is long," says the first spider.

"And he has nothing to fear," says the second.

"Nothing. Exactly," says the third.

I'll be glad to deliver this message. If I recall, the receptionist has the dreamiest eyes I've ever seen.

Vampire

FIRST ILLUSTRATION BY GEOFFREY SMITH
FINAL TWO BY ANITA ZOTKINA

The vampire was fat. I mean, really fat. I'd say morbidly obese, but I don't know if it's right to use the word morbid about someone who never dies. He was sitting behind a desk, looking at me and softly rapping his chubby knuckles on the mahogany surface. He pierced me with his beady eyes and said, "You want to what?"

"I, uh—"

"You're not even a vampire! You're a human. You're food. Why shouldn't I eat you right now? No. Don't answer. Don't even speak. I'm the one with the answers, and the answer is that I shouldn't eat you because you wouldn't taste good. I can tell by your smell. Your blood is probably runny and weak-tasting. Not very nutritious and not worth my time. And did you have garlic for dinner? Sautéed garlic? I can smell it on your breath. Good stuff. It's the one thing I miss about not being human."

I wanted to tell him I didn't have garlic with dinner (steak and potatoes, butter and sour cream, no garlic, not even chives), but figured this might be counterproductive.

He said, "An interview? For what magazine? Blood Times? New York After Dark? Or some human magazine? It's got to be a human magazine, 'cause I can't see any vampire magazines taking something written by food. There are some vampires who believe that food isn't really sentient, and that even when food "says something" it doesn't really say something. How do they put it? Oh, 'Humans vocalize, but is it really language? And they writhe, but do they actually feel pain?' Hey, what say we find out?"

I thought it best to remain silent.

He continued, "Is the interview for a blog? It's not for a blog, is it? If so, don't waste my time. I

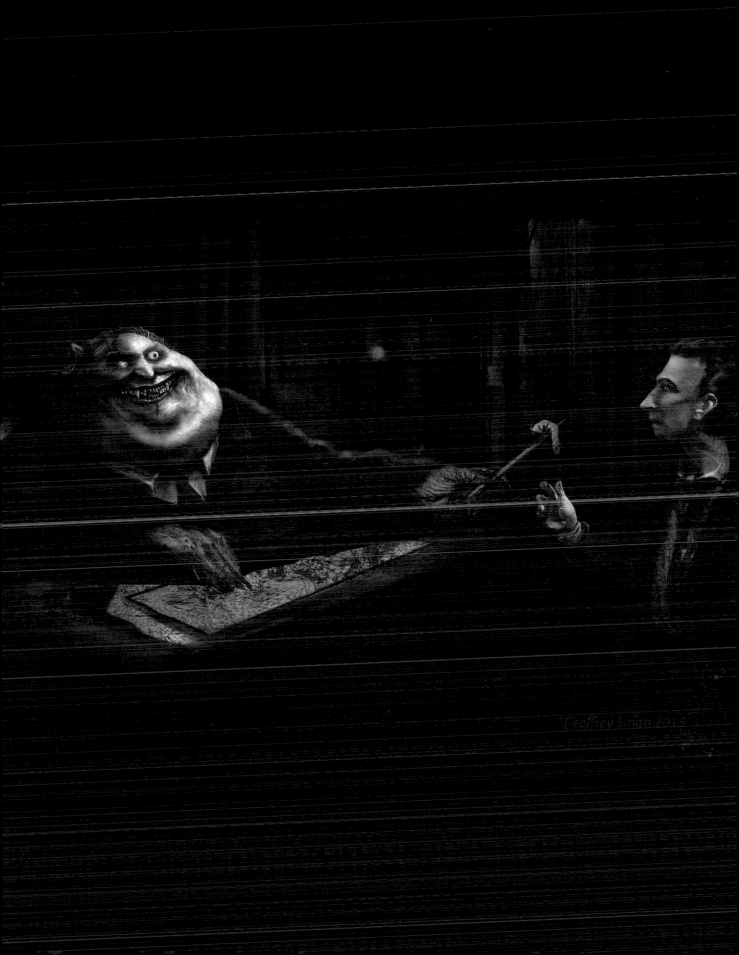

like the Internet and everything, but everybody and his mummy has a blog these days. I'd want the interview to be in print. I'm old-fashioned that way."

I took in a breath to say something.

He said, "If it's not for vampires to read, but for humans, I just don't know if it's a good idea for me to be doing this. Right now we have things pretty good, you know what I'm saying? This is truly the scarlet age for vampires. You know why?"

I knew better than to even try to answer.

"I'll tell you why. Because there are so goddamn many humans. That's why I can be so picky. That's why I haven't eaten you. Look, you got a choice between eating a ripe luscious apple or a rotten wormy apple, which do you choose? Don't answer, it's a, whadyacallit, rhetorical question.

"And you know why else this is the scarlet age for vampires? Because food doesn't believe in us anymore—that is, if they're capable of belief or not-belief—and so food no longer even takes precautions. No crosses on the walls. No garlic wreaths above their doors. No sharpened stakes by their beds. It's like taking candy from babies. Actually, now that I mention it, babies are some of the best candy.

"And you know why else this is the scarlet age? Because of refrigeration, that's why. Now, some people seem to think the invention of refrigerators and other items by food means food is intelligent, while others think it's merely instinctual activities on their part, like ants carrying around pieces of dirt to make their tunnels. But in any case, it works for us! No more worries about food spoiling. Speaking of which, would you like a popsicle?" He reached to the side of his desk, opened a small refrigerator/freezer, pulled out two, then handed me one.

I pulled off the paper, and saw it was a frozen finger.

He said, "As the advertisement says, 'Deliciously slurpy blood consistency with a delightful crunchy bone center!'"

I stared at it.

Looking disappointed, he asked, "Oh, not hungry?"

I handed him back the finger. Having finished the first, he started to suck on it.

He continued, as though peeling paper off a frozen human finger and eating it required no more thought than eating a hot dog or frozen blueberry, "So the reason I don't think I should do this interview is that if it's for a human audience I don't see how it would be in my interest or in the interest of my fellow vampires to let food know we really exist. Although if food is as stupid as some people say, then it wouldn't really matter how much I say, would it?"

He was silent for a moment. "But things aren't perfect. Not by a long shot. The worst thing about humans these days is that they aren't organic. That's another reason I didn't eat you. You

were squinting like you have a headache, and I'll bet my life . . ."

He paused, waiting for a laugh.

When none was forthcoming, he said, "Get it? I don't have a life to bet." He paused again. "Anyway, I'll bet you have aspirin in your system. I don't like it. Thins your blood. And aspirin is the least of our problems. All that crap humans put in their bodies makes their blood taste awful. You know what's the worst? Artificial sweeteners. Terrible aftertaste. Worse even than all those fancy medicines with names nobody can pronounce. And none of that junk is healthy. We vampires may not be living, but we still care about our health."

I almost felt sorry for him.

He finished his popsicle, then said, "The only reason I'd do an interview would be to tell humans to stop polluting themselves so they'll taste better. Do you think you could convince them to do that for us? Or are they too selfish and stupid?"

Then he opened the fridge again, pulled out a chilled glass of red liquid, tilted it slightly toward me.

I asked, "What's in it?"

He said, "A delicious blend of eight types of human blood."

I shook my head.

He drained the liquid in one long draught, put the glass on the desk, wiped his lips with the back of his arm, winked, then said, "You coulda had a B8!"

He belched, then leaned back in his chair, closed his eyes. When he finally opened them again he said, "I'll be honest with you. Between television, email, and Facebook I don't have much time anymore . . ."

"Wait," I said. "Vampires are on Facebook?"

He gave me a look that said he thought I should know better, then said, "Of course. Vampires run Facebook."

I said, "That explains . . ."

"Yes," he said. "Why else do you think Facebook is so good at sucking away people's lives?"

I nodded.

He said, "In any case, what with the Internet and all I don't have time to go hunting anymore, so I almost never see food on the hoof. Most of it comes pre-packaged." He gazed at me. "I guess what I'm trying to get at is that I'm very interested in you, and in your opinion. I'm dying to ask you—get it, dying?—a very important question."

I waited.

He said, "The important question is, what do you think of me? I've been doing all the talking

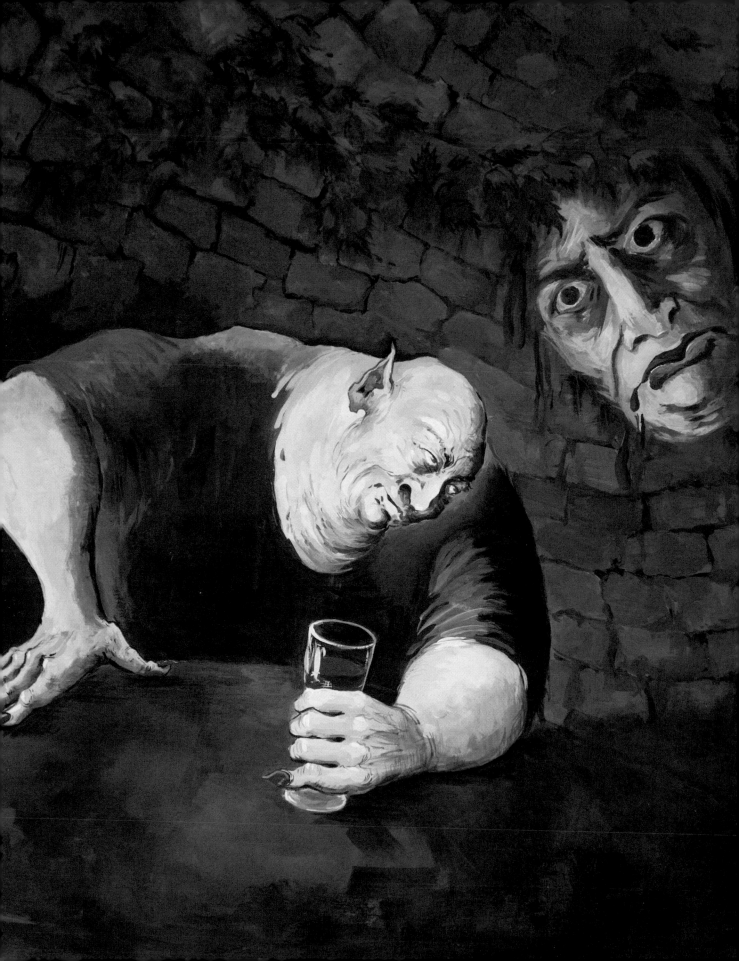

so far. You talk about me for a while. What was your first impression? What do you think of me now? Are you scared to be sitting across from a vampire who could suck out all your runny weak-tasting blood? Am I how you imagined a vampire would be?"

I wasn't really sure what to say.

Not that it mattered, because he didn't wait for me to answer. He said, "Of course it's silly of me to even ask. How could I expect food to have a meaningful opinion?"

He tilted his head back at a slight angle, looked down his nose at me. He turned thoughtful. "It's been a long time since I was human. I almost don't remember what it was like. I don't remember being a living animal. Oh, we vampires still have sex, and we still eat, obviously, and we still defecate, and we still do all those things you do, like work jobs or run businesses, watch TV, look at the internet. We still can see clouds slide in front of the moon, still feel cold wind on our skin, still sleep, and even, after a fashion, dream. But you know, or maybe you don't, that none of this makes us alive. None of these are the markers for living. Just like, by themselves, none of these are markers for sentience, obviously, since food can do all of these.

"So, what does it mean to be fully alive? What does it feel like to be fully alive? I've forgotten, and for so long I've wanted to ask a human, but the humans I've met have mostly been pre-packaged, or, back when I had more time, about to be prey. What is it that makes you alive, that makes you not undead?"

I waited a long time. I wasn't used to him not answering his own questions. But I didn't have an answer. He eats. I eat. He has sex. I have sex (well, not for a good long time). He sleeps. So do I. He perceives the world around him. So do I. He says he runs a business. I go to school and work a shit job. Why is he not living? Why am I not living dead?

This was not going how I'd planned. If I wanted to salvage the interview I'd need to start talking, fast. I thought I'd open by appealing to his ego. I said, "I'm extremely interested in your opinion. That's why I came to you. As a philosophy grad student, I am pleased with the exegesis I've developed concerning vampiric lore. To really understand the exegesis you probably have to know a little Wittgenstein, some Hegel, a touch of Nietzsche, and certainly a lot of Ayn Rand—"

He interrupted me, "She was a vampire, you know."

I chose to ignore his interruption. "Despite your lack of a philosophical background I should be able to lay out the basics for you in a way you can understand."

His eyes grew even more beady.

I kept going. "My fundamental thesis is that vampires can be seen as a metaphor—"

He rose slightly from his chair. "What? Vampires, a mere metaphor?"

I responded, "Well, rather more of a synecdochic metaphor than an absolute metaphor per

Hans Blumenberg's metaphorology, although there is a touch of the latter, as well as, if I may permitted a small bon mot, a few characteristics of the (un)dead metaphor—"

He bared his teeth and snarled.

I presumed that was because he wasn't familiar with Blumenberg's vital work, and didn't enjoy feeling ignorant. Oh well, a lot of people, and vampires, I guess, feel intellectually inferior when I talk with them. They should read more.

I persevered. "Vampires are a metaphor for humans who are stuck existing in destructive or non-life-affirming loops, who are narcissistic, who are neither fully living nor yet dead."

He hissed, "Are you saying . . . ?"

I waved away his interruption. "You said you wanted to know about the difference between the living and the undead. I'm answering your question."

He pointed his finger at me. His nail was long and sharp. "I could slit your jugular with one flick of my wrist."

"Do you want to talk or not?"

"Do you want to live or not? How would you like to be killed by a metaphor? I can imagine the headlines: 'Philosophy Graduate Student Killed for Misuse of Metaphor.'"

I'd had enough of his intellectual bullying. "Why are you being such a fascist? Why do you disallow any opinion that differs from your own? Just because you've been around for hundreds of years, does that mean you have nothing to learn from me?"

The vampire roared, "You come into my home and you insult me. Did I ask you to come here? How did you find me?"

"At first, like everyone else, I didn't believe in vampires. But then I developed my exegesis, and thought it would be fun to tell it to some goth vampires, you know, those kids who dress in black and put on white makeup and pretend to suck each other's blood."

He rumbled, "I don't know whether to pity them for being pathetic wannabes or hate them for being dirty phonies."

"One person pointed me to another, who pointed me to another, who pointed me to another, until someone said she'd heard rumors about a real vampire, and after asking around some more, here I am."

He smiled in a way that made me more uncomfortable than his roaring, and asked, with a seeming nonchalance, "And these others, they know you are here?"

I should have just lied and said yes, but epistemology—the study of how we know—is one of my specialties, and I couldn't help myself. "Do they know? How do we know if they know? How do we know what anyone knows? Isn't that the question? Do they even know if they know?"

He kept smiling, and may have slightly licked his lips. "So, please, do continue telling me about your exegesis of the . . . metaphor."

He wanted to hear my analysis! This was more like it. I said, "Well, first, vampires can't see their own reflection in a mirror. This represents the inability of the narcissist to see himself as he truly is, or to reflect on his own attitudes and behavior . . ."

Beneath the layers of fat on his face I thought I could see muscles moving in his jaws, as though perhaps he was clenching and unclenching his teeth. But he was still smiling and nodding as if to encourage me, so I continued, "Likewise, as sunlight burns vampires, dispels them, so 'shedding light' on the behavior of a narcissist or some other person stuck in destructive or self destructive behavior burns that person, dispels his illusions of his own grandeur. Destroys his self-structure. If he clings too tightly to his narcissistic self-definition it will destroy his physical being."

Yes, the muscles were definitely working in his cheeks. I presumed this was because I was shedding light on his issues. His defensiveness was the best confirmation I could ask for concerning the accuracy of my analysis.

The interview was going far better than I had dared to hope.

But I still wasn't quite happy. I wanted to push my analysis forward. "Vampires have no soul, just as narcissists have no depth. They are in eternal torment, as narcissists are forever dissatisfied."

The vampire's face was now blank, and still as a piece of silvered glass.

I took his silence as consent for me to continue. "Vampires can't cross running water. Water, as you know, can represent life. Extending our metaphor we see that narcissists are stuck in their own little worlds, their own little coffins to which they must retreat whenever there is any possibility of light being shed on their self-destructive personality structure, and they cannot fully enter the stream of life, the river of life. The same is true if we perceive water as representing the unconscious: vampires, as narcissists, can never really dig deep to understand their own unconscious motivations . . ."

I paused to see how the vampire was taking all of this.

"Do please continue," he said. "Your comments are very, shall we say, illuminating."

I was delighted he was receiving my analysis so well, though I knew it must be very difficult for him to hear. "And of course vampires suck blood, just as narcissists suck the life out of every being near them. The metaphor works, does it not?"

The vampire politely stifled a yawn, then looked at me, saying nothing.

I found his yawn a bit insulting. I'd searched him out for this interview, precisely so I could

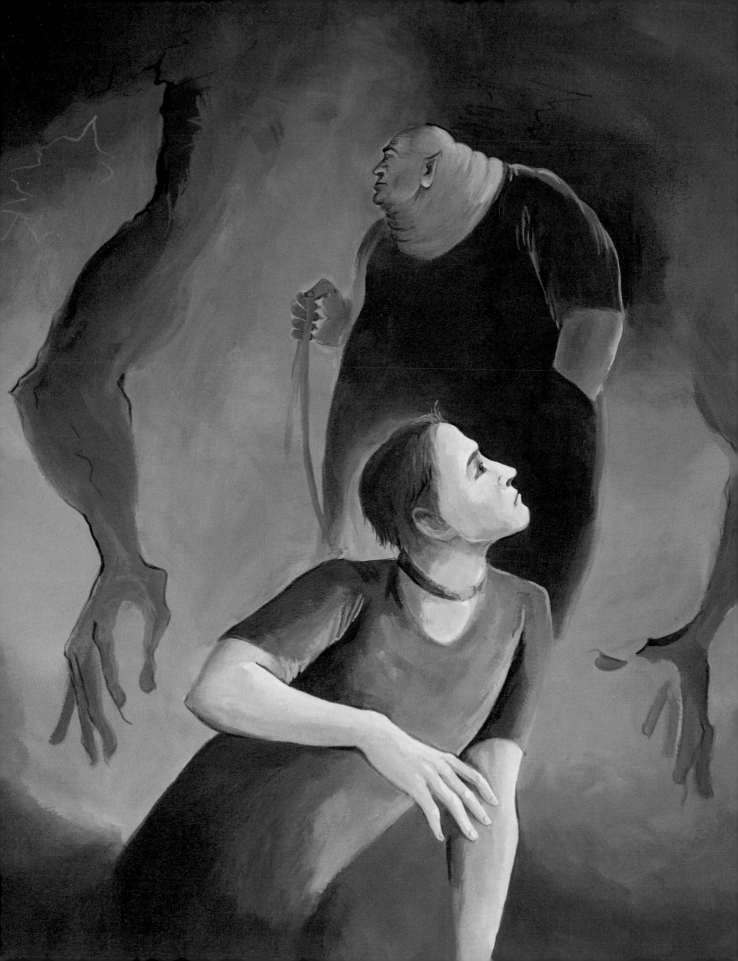

tell him my analysis, and this was his response? Trying to keep the ice out of my voice, I said, "I hope I've not bored you too much."

He smiled. "On the contrary. I find you quite amusing."

Amusing? That was worse than boring. No one had used that word to describe my theories since that disastrous blind date a few years ago. I used the same line that my date said to me right after she made the "amusing" comment: "I guess I should go."

"Oh, no," the vampire said. "I have decided you will stay."

"You have . . . What? What gives you the right?"

He pointed one long fingernail at me. "You shall not be my food. Instead you shall be my pet, and you shall stay in this room with me to entertain me. But as amusing as you are, your constant vocalizing annoys me. You yap too much."

I stood up and said, "I'm going to walk out the door." But I was afraid to turn my back on him, so I stayed in place.

He said, "Your statement raises questions of free will, don't you think? Do you have free will? Can you actually walk out that door?" He paused. "See, I, too, can spout philosophy when I choose."

I backed away from him.

"As a pet you will need to be housebroken, and crate- or coffin-trained, and you will be taught to do pleasing tricks, and most especially only to vocalize on command. To train you I will use that wondrous invention of the food— where would we be without our food servants to make these gifts for us?—called a shock collar."

This was not going to happen to me. I was not his pet. I was a philosophy grad student. I turned and ran for the door.

Until the moment he caught me, and until the moment he had the shock collar fixed around my neck, I had no conception that one so big could move so fast.

Troll, Part II

ILLUSTRATIONS BY ANTHONY CHUN

When I found the female troll, she wasn't breathing. Neither was I.

I never would have seen her if I hadn't already been told where she was, and how to see her.

She wasn't breathing because she was doing what trolls have been forced to learn to do: she was hiding.

There are many ways this culture drives species extinct. It can hunt them until there are no more to kill. It can deprive them of food. It can destroy their homes. Although some trolls have been killed directly, mainly trolls have been deprived of their homes, through the destruction of forests. They have not been particularly deprived of food. This is because one of their sources of food is humans.

Which is why I wasn't breathing. I didn't want her to make any food-choice decisions before she had a chance to learn why I'd come. I didn't want to be killed and eaten, although I was more worried about the former than the latter. If she did the former, it would no longer matter to me whether she did the latter.

The male troll had given me two sets of directions on how to find her, one incomprehensible and one only kind of difficult. The incomprehensible set consisted of descriptions of physical landmarks: "You turn left at the old snag who has a large limb pointing toward the sun in the afternoon, and follow that stream up to where the third stream comes into it on the right: don't count rivulets. You'll know the stream. Then hide for hours until you feel it's safe to cross the flat wide space with all the huge metal missiles hurtling down it," and so on.

The kind of difficult set followed an entirely different logic, one I could understand: "Get on

Highway 198," he said, tracing the map with one of his big fingers, "And stay on that to County Road 15. Turn left, stay on that for seven miles, to where it hits Highway 214 . . ."

I wish he would have just handed me a GPS with the address programmed into it.

He'd already told me why he couldn't walk the roads. I asked why he didn't just ride in the back of my pickup. He was too large to fit in the cab, but could easily squeeze into the bed. I could cover him with some tarps or hay, and off we could go to meet his sweetie.

I've often heard the phrase "break out in a cold sweat," but I'd never before really seen it, nor had I smelled it (and you've never smelled a cold sweat until you've smelled a troll's). The troll's eyes grew wide, and he said, "Get into a machine? Machines steal your souls. They're made by devils. If I get into a machine I will be turned into . . . into a monster."

I didn't force the point. Here he was, talking his monster nonsense again. The important thing was that I thought I could follow his map directions. It's a good thing my life didn't depend on me understanding his physical directions. Can you imagine how hard it would be to find your way using only natural landmarks?

My life did, however, depend on conveying the right message to the female troll. If I conveyed the wrong message, she might get scared, and if she got scared she might open her mouth wide, show me her sharp teeth. The male troll told me again and again what to say to her. It was in troll.

I asked, "Why can't I give her the message in English?"

"She couldn't be sure it was from me."

"I could give her details only you would know."

"How would she know you hadn't tortured them out of me?"

"Oh, come on, do people really do that?"

"Do you people ever do anything else?"

He had a point. But then I thought, "Why won't she think I tortured you into teaching me that phrase in your language?"

"Because you're so arrogant you don't think any language other than your own even exists."

My face clearly showed how insulted I was.

He asked, "How many words of chickadee do you know?"

"They cheep . . ."

"Those are only cheeps to your ears. Chickadees tell wonderful stories, with their 'cheeps' and by wagging their tails and tilting their heads. Chickadees could tell stories that would make you roll on the ground laughing, if you only believed they could speak. Same with banana slugs."

"They don't even talk."

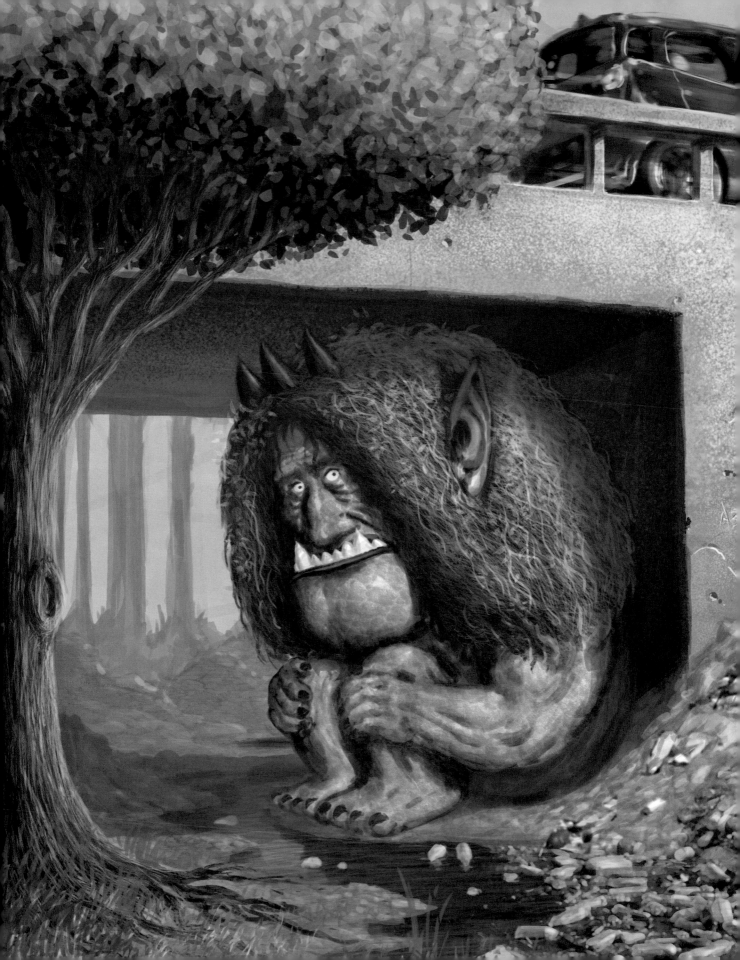

"Thank you for making my point. Just because you can't or won't understand their language doesn't mean they aren't speaking. Slugs are delightful company, courteous, courtly, and they're among the best at telling ribald tales. Did you know they're hermaphroditic and that sometimes they have sex for days at a time? And did you know . . ."

"What?" I exclaimed, thinking about 48-hour sex.

He evidently thought I was dubious not about the marathon sex, but about the slug language (about which I wasn't even dubious, but just disregarded without a thought). So he said, "Banana slugs discuss everything. They deliver poetry (very bad poetry, unless it's about slug sex). They sing songs (still not so great, except on that same topic). They do, however, tell some great stories about rain."

"Rain?"

"Don't you humans know anything?"

"Banana slugs can talk?"

"That is why no one would ever torture one of us to learn our language. According to you, you are the only ones with anything to say, or even the means to say it."

"No wonder we're so unpopular."

"Among other problems."

He tried again to get me to be able to make the troll sounds. I had no idea what I was saying. For all I knew, it could have been, "Try this one medium rare, with a garnish of lamb's quarters." Or it could have been, "This one is on our side. Now we can find a way to meet and resurrect our love." Of course, learning the lines by rote it was also possible I could accidentally change one syllable and change a hypothetical meaning from something like "Kiss this guy's ass" to "Kick this guy's ass," or "I want you to kiss him" to something like "I want you to kill him." Frankly looking at a troll's mouth I don't think I'd want to deliver any of those messages.

In any case, he taught me the message, I drove to the right place, parked a half mile from the stream, walked to the bridge, went underneath it, and there she was. I gave her the message, and she said something back, in troll.

I said, "I'm sorry, I only speak English."

She said, in English, "No reason to apologize. English isn't an easy language to learn. Simpler grammar than red cedar, but not easy."

And thus I began my service as a message carrier for trolls. At first the messages were short and verbal, but later, the trolls began to give me long letters in English. They weren't in the trolls' language because trolls, as the trolls put it, are not so primitive as to have a written language. As a point of honor I was never even tempted to read them.

The trolls often lamented that they really wanted to communicate in song, but when I offered to record their songs for them, they started their crazy monster talk. Each one asked, aghast, as though I'd suggested they kill a close blood relative, "Why would we allow you to murder a song?"

Whatever.

I asked the female troll once why they didn't just use chickadees to carry their messages, since chickadees were obviously so much more intelligent and communicative than humans.

She didn't catch my sarcasm, and answered sincerely that yes, chickadees were smarter and generally more reliable, but like the other troll, she missed, as she called it, a face that was at least somewhat trolloid.

Given that the drive was fairly short, and given that being able to deliver messages for trolls was kind of exciting (clearly, none of my friends could claim something like this—though I couldn't brag to them since I was sworn to and maintained secrecy) I would have been happy just delivering their occasional love notes to each other for as long as they wanted me to.

But then something happened that threatened to change everything. I learned that someone had filed a plan with the state to cut the small patch of forest where the female troll lived. She didn't know where she could go. There was so little forest left, and we couldn't figure out why they had to cut this patch near this little bridge over this little stream that was home to her and so many others (the trolls had introduced me to chickadees and other birds, and I had made the acquaintance of several slugs, who were indeed as courtly as promised).

I asked if this might be a good time for her to go ahead and relocate near the male troll she loved. I would help her move, in whatever way she would be comfortable.

She said, "But this is my home."

"They're going to cut it."

"But this is my home. I cannot and will not leave my home."

"Then you will die here. That is not good. I don't want you to die."

"I don't want the forest to die."

"So what will you do?"

She thought a moment before she said, "I guess I will do what trolls have been doing since humans forgot how to behave: I will die with my forest."

"That's what trolls do?"

She looked at me scornfully, said, "You don't?"

I didn't say anything.

She began to sing. It was clearly a song of mourning. I could tell she had a lot of practice

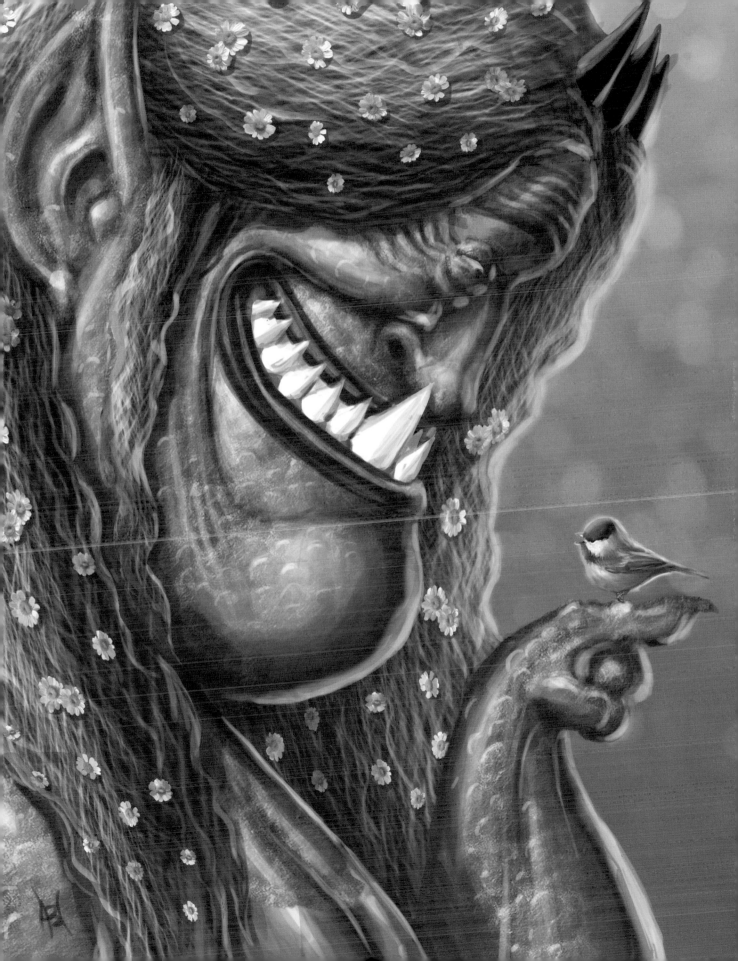

singing mourning songs. I cannot, of course, describe the words to you, if words there were, or even the melody, if it had one. But I can describe the song's effects on my body. I felt as though someone had cut off my arms, my legs, my ears and eyes and nose and mouth and had removed my heart and lungs and genitals and skin and every other organ. I felt as though I were being systematically dismembered. I felt as though I could not breathe, could not see, could not hear. I felt as though I were being killed.

I have never felt as empty as I did when the song was done. There was nothing left, either inside or out. There was nothing to live for. Everyone and everything I loved had been destroyed.

When the song was done I felt water on my cheeks.

I had never cried over anything so important.

I didn't know what to do.

She asked, "What do humans do when faced with this sort of destructiveness?"

I wanted to tell her that humans normally file regulatory appeals and lawsuits, publicize the destruction, and so on. But then I realized that's not true. A good portion of humans actively participate in the destruction, and the rest spend most of our time sitting on our butts and vaguely hoping that somehow more bad things won't happen. I said, "Nothing helpful."

We were stuck. I didn't want her to die. She wouldn't leave the forest. And we had no idea what to do.

To be continued . . .

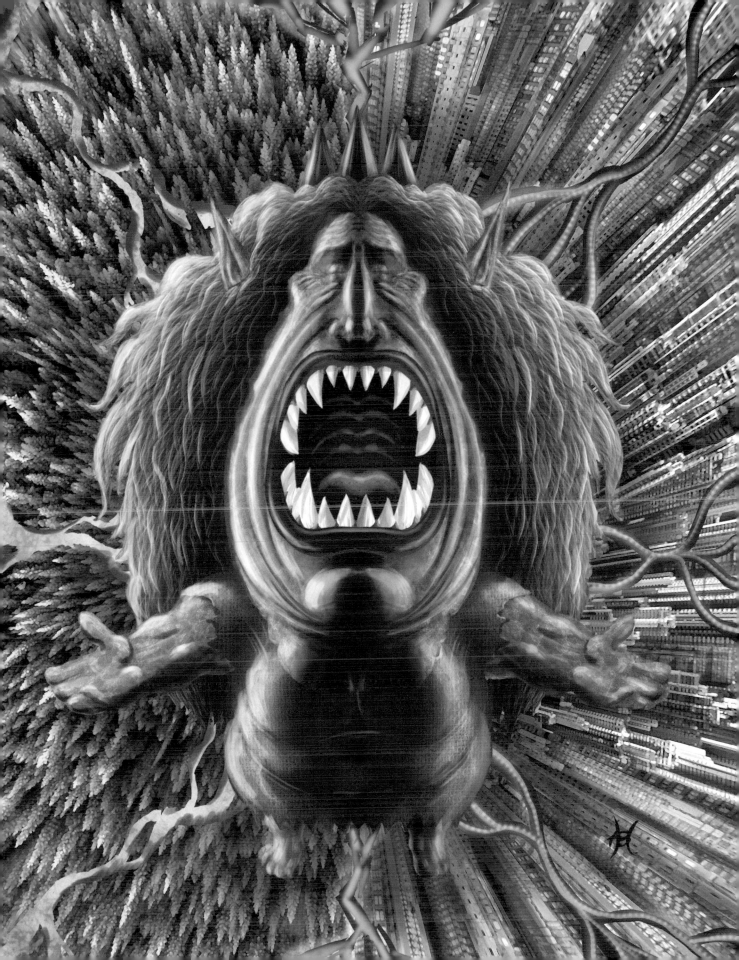

Orc

ILLUSTRATIONS BY ANITA ZOTKINA

"**I**f I could torture and then kill only one human from all time, I think it would be J.R.R. Tolkien." The orc, sitting across the rough table from me, looks like he means it. He continues, "I gave that, that, that . . . that Englishman," he says as though he were swearing, "Hour after hour of interviews about orc culture and history and language, and then did you see how he portrayed us? He was a crafty one, all right. He even got me to talk about our sexuality. 'I promise I'll show you in a good light,' he says. 'It will be a friendly series of interviews for a book I'm writing about the troubles'—'troubles,' he says to me, oh-so-delicately—'between you and the dwarves and elves and hobbits.' Fucking hobbits! At the time I'd never even seen a fucking hobbit! And you notice he didn't mention humans. I guess all that noble Aragorn stuff just kind of slipped his mind. Troubles! That's what he calls land-theft and genocide. That's when I should have told him he could stuff that interview idea right into his pipe and smoke it. But he promised he would show us in 'a good light.' And I bought it."

The orc doesn't look how I expected. He looks somehow a little bit more, I don't know, human? Ugly, of course. Dark-skinned. Thick features. But kind of human, if you're in a forgiving mood.

He continues, "I guess I was desperate after all the bad press orcs and goblins have received over the centuries."

"Goblins?" I ask.

"Goblins," he says, "are our cousins. But a lot of humans mistake us. We probably all look alike to them. Anyway, we're on friendly terms with goblins, and I thought I'd be doing a good thing for us both, getting us a little good press for once. But I should have known better."

"Wait . . ." I start to say something in defense of humans, but he cuts me off.

"And that Englishman used my desperation to his advantage. He said he'd read everything he could read about us, and it was all so awful that he wanted to hear our side so he could present a 'fair and balanced' view of the situation. Fair and balanced? You call *The Lord of the Rings* fair and balanced? I'd like to give ol' J.R.R. a fair and balanced walloping, one smack on each side of the head for every lie he told about us."

Honestly, I'm not sure how to respond to this strange being.

"And there was no Sauron," he continues.

"What?"

"None. I confronted Tolkien about that later and he said, 'Sauron was a literary device necessary to generate drama. No Sauron, no story.' Nonsense. There was also no invasion of Gondor. Nothing like it at all. Instead there was constant expansionist pressure by dwarves and elves and humans, and yes, even the fucking hobbits. They were always moving into our territory—territory they called 'wastelands'—until the dwarves put in their mines, the elves their 'forestry projects' (complete with Environmental Impact Statements that always declared each new project would have No Significant Impact), the humans their cities, and the fucking hobbits their fucking farms."

I've had just about enough. "How can you sit here and tell all these lies?"

The orc throws up his hands, says, "That's what I said to Tolkien! He blamed it on his agent and publisher, said they both told him the other story wouldn't sell."

"You're out of your mind."

"He's probably right, it wouldn't have. But does increased sales excuse the telling of lies?"

"I don't—"

"That's really the central question of discourse among your people, isn't it?"

"No! Well, yes, of course. What else would it be? Wait! No! Why—"

"If you told the truth you couldn't keep on with all the conquering, could you? And then where would you be?"

I sputter, "We'd be . . . What? No! I don't—"

"Did you ever notice that in The Hobbit, the dragon was considered greedy, and the dwarves weren't? And did you ever ask yourself why? I mean, the dragon—Smaug—was greedy because he hoarded the treasure, right? Well, I knew Smaug and he wasn't such a bad guy; kind of surly at first, and he had halitosis, but I liked him. He wasn't as greedy as his neighbors outside the cave, those dwarves. Think about it. What did the good ol' law-abiding dwarves do after they killed Smaug and stole his treasure? They hoarded it themselves. Why aren't they considered

greedy? Did you ever ask yourself that?"

I stare at him. "Of course not."

He returns my stare, then asks, "Why not?"

"Because the dwarves were the ones who made it."

The orc laughs. His laugh isn't lyrical, like I'd expect of an elf; or cute, like I'd expect of a hobbit; or hearty, like I'd expect of a dwarf; but nor is it demonic, like I'd have expected of an orc.

He says, "No, the mountains made it. And the dwarves disemboweled whole mountains to get it. Do you see it yet?"

I don't know what else to do, so I just frown at him. Finally I say, "Tolkien's work was really important to me when I was a teenager."

He's no longer laughing. He says, "And so that means . . ."

"Quit picking on him."

He smiles with one side of his mouth. "Okay, instead of Tolkien on the torture block, let's make it Gary Gygax."

I have never before in my life had my mouth drop open in shock, like the cliché they put in too many books, but that's exactly what happens. If I were holding a glass of water, I would have spilled it. If I were standing, my knees might have buckled. If I were a proper Southern belle, I probably would have gotten the vapors.

Tolkien? And now Gygax?—one of the creators of Dungeons and Dragons? He's saying he wants to torture and kill the heroes of my youth. This is like someone of another generation hearing the orc say he wants to torture and kill Elvis Presley; or Cagney and Bogey; or John, Paul, George, and Ringo, except that anyone who has heard "Silly Love Songs" or "Band on the Run" might agree about Paul.

He begins, "Did you ever think about the fact—"

I cut him off by standing to leave.

He reaches out and lightly grabs my arm. "Hear me out."

"Don't touch me, you vile thing."

He releases me. "That's exactly it, isn't it? You and Tolkien and Gygax and all the rest, don't you ever get tired of trying so hard to pretend we're things? Don't you ever get tired of becoming angry or indignant—or perhaps worse, bored—when we try to tell you different?"

I turn to face him. "I was sitting here minding my own business when you came and sat opposite me. I tried to ignore you. I tried to ignore your ugliness. I even tried to ignore your smell. But now you insist on talking to me, and worse, you insist on talking about torturing people who

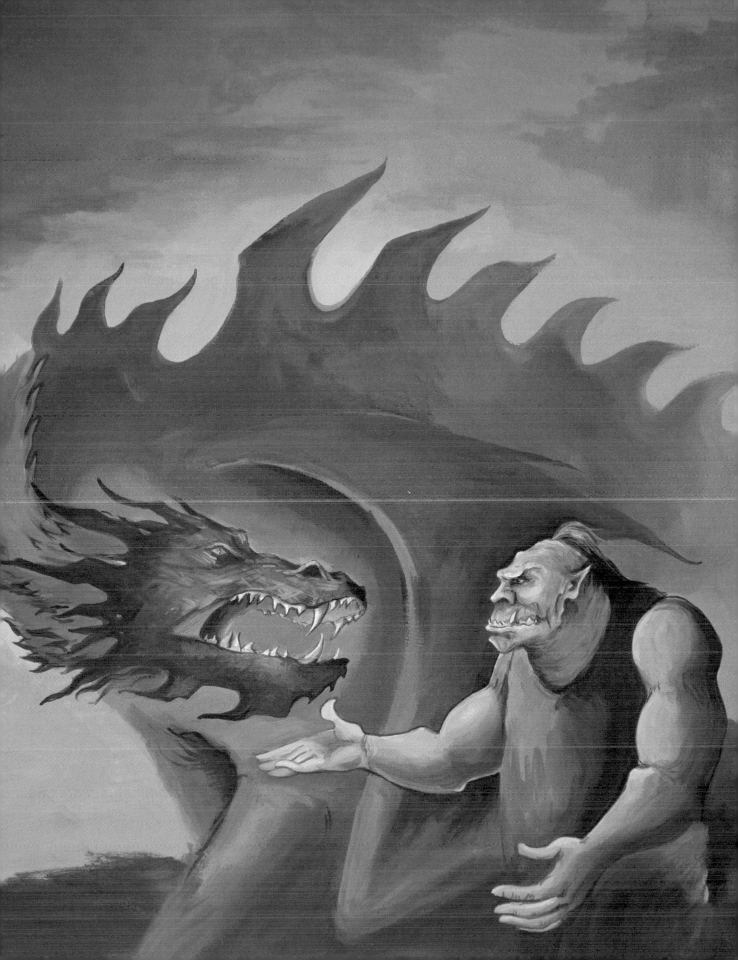

influenced me deeply when I was younger, and you touch me when I don't want to be touched. Then you act like I'm the one with the problem. What have I ever done to you to deserve these attacks?"

"That's what we've always wondered about you and your kind."

"Don't try to turn this around and make it my fault. I've never done anything to you."

The orc nods. "How would you feel if I treated you like a thing?"

"I've never treated you like a thing."

The orc continues nodding. The way he nods kind of pisses me off.

He keeps doing it.

"Stop that!" I say.

He keeps doing it.

"Are you doing that just to annoy me?"

He asks, "How would you feel if I called you a thing?"

"I never called you a thing," I say.

He stops nodding, then starts again.

"Cut that out," I say.

"How would you feel if I called you vile?"

"I never called you vile. And besides, you said you want to torture and then kill two of my heroes. If that's not vile, then I don't know what is."

The orc says, "The word vile comes from the Latin root meaning cheap or worthless. So which is more vile, to publicly declare another race, although, to be precise, we're a different species, to be cheap or worthless; or to want to torture those who do this vile thing?"

I say, "Of course I know where the word comes from," although of course I don't. But I'm not going to let this damned orc know that. I don't know whether I'm more confused by what the orc says, or by the fact that the orc knows Latin, or now that I think about it, English.

"Other species besides humans have knowledge, you know," the orc says. "Is it more vile to consider another species to have no knowledge, or for this other species to let you know they do? You must realize that if you keep telling some group of others that they're cheap or worthless, that their existences have no value, they may, in time, if you don't listen, write the story of their value in your blood. And would you blame them?"

"Are you threatening me?"

"With what?"

"With cutting me up so you can write your value with my blood. Or with torturing me to death."

The orc grimaces, leans back in his chair. "Let me ask you something," he says. "Did you ever play Dungeons and Dragons?"

"Of course," I say. Sometimes, all these years later, I still think fondly of my favorite character, a 46th level fighter who was the scourge of evil creatures everywhere. He would have made short work of this orc, hacked him into little bits with his +6 magic sword.

He asks, "Were the characters you played usually good?"

"Oh, yes," I say. "You weren't normally allowed to play evil characters, and I wouldn't have wanted to anyway."

"And lawful?"

"Yes." The morality of Dungeons and Dragons characters are generally rated on two scales, from good to evil, and from lawful to chaotic. The first has to do with whether you normally do good or evil deeds. A good deed would be slaying an evil monster, then taking that monster's treasure, and an evil deed would be robbing from or killing someone who is good. And the second has more or less to do with how consistent or predictable you are. So, for example, a vampire would be both evil and lawful because if it sees you (and you're a human) it would pretty consistently want to suck your blood.

"And were the characters you played usually human?"

"Yes, or sometimes dwarf or elf or hobbit."

"Fucking hobbit, you mean."

"Well . . ."

"But you never played an orc?"

"Oh, no. Like I said, evil characters weren't usually allowed."

The orc smiles.

I don't like the smile. I think he's trying to make me feel guilty, or trying to make me feel . . . I don't know . . . something uncomfortable.

"And why were orcs evil?" he asks

"Why are you cross-examining me? Are you some sort of orc Perry Mason?" I laugh at the image. Orcs in a court!

"I'm just asking some questions."

"Of course orcs were evil."

"How did you know?"

"Those were just the rules."

"Were cities important to these games?"

"Of course they were."

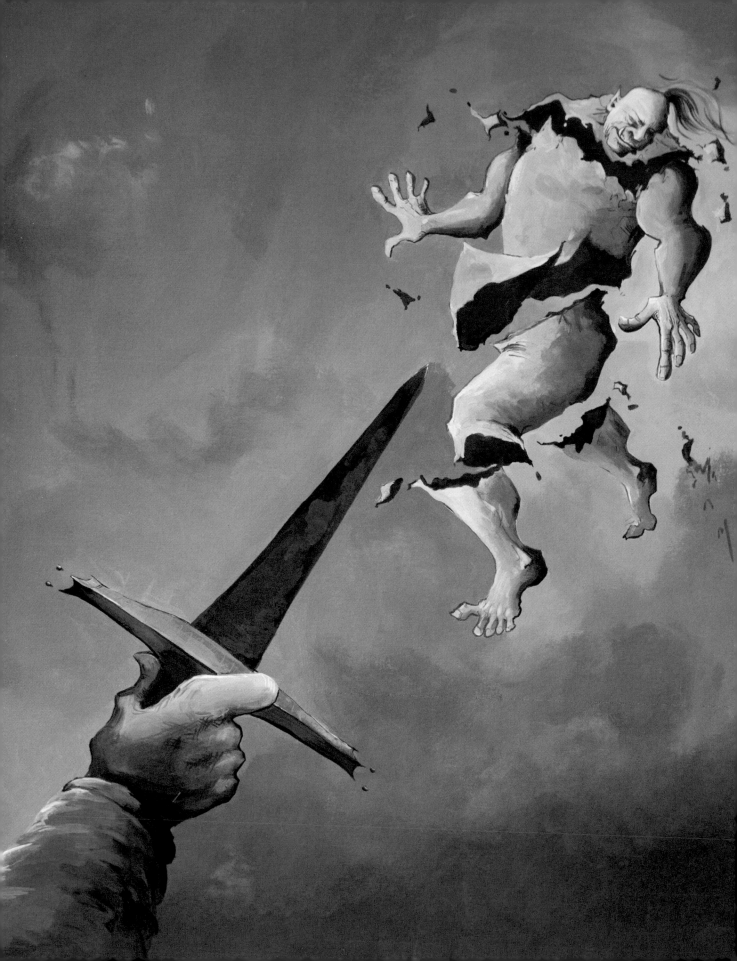

"Why?"

"Don't you know? Did you never play it?"

The orc says, drily, "Oddly enough, playing that game has never been a high priority among my people."

"You should," I say. "It's really fun."

The orc's face doesn't show much expression.

I say, "Cities are important because that's normally where you start the game. That's where you buy supplies, and then after you buy supplies you go out and explore the countryside and slay monsters and gather treasure, and after that you come back to the town to sell the treasures and buy more supplies."

The orc rubs his eyebrows. They are thick and not very elegant. "Where do the supplies come from?"

"A store. Where do you think?"

"And where does the store get them?"

"I don't know," I say. "I never thought about it."

The orc waits.

"I guess the food comes from the countryside. And then the swords come from swordmakers and the bows and arrows come from bowmakers and fletchers." I make sure to use the word fletchers because he lectured me about the word vile and I want him to know he's not the only one who can get fancy about words.

He asks, "And where do the swordsmiths . . ."

He pauses and smiles slightly after he says that word. I can't figure out why.

He continues, ". . . where do they get the metals for the swords and the bowyers and fletchers . . ."

There's that pause and slight smile again. This kind of pisses me off, too. What is it with his gross mannerisms?

He continues, ". . . and where do they get the wood for the arrows?"

I don't even have to think about this one. "From the dwarves and the elves." But I wonder if somehow my answer is going to make him mad.

It doesn't seem to. He asks, "And where do the dwarves and elves get their metals and wood?"

I frown again, this time not from annoyance, but because I'm thinking. Finally I say, "From mountains and forests."

"So in these games, cities are generally considered good places . . ."

"Not all of them. Some cities have a lot of thieves who will try to steal your treasure."

"The bad thieves steal the treasure of good people."

"Yes, exactly."

"But there are usually a lot of good people in the cities, too?"

"Usually."

"And these good people go out into the countryside—"

"More the wilderness, really."

"Into the wilderness, then, and they kill evil monsters and take their treasures . . ."

"Yes, but it's not really taking."

"Do orcs live in cities?"

"Oh, no," I say. "Except some who sneak in sometimes to steal. Mainly orcs live in villages or camps."

"Do the orcs ever mine, or log, or farm?"

That's a good question, I think. I say, "No, I don't think they ever learned to do that. I don't think orcs are smart enough to do those things."

The orc blinks twice.

I say, "Nothing personal."

"I guess the question I'm trying to get at," says the orc, "is what the orcs did that caused them to be labeled evil."

"Well, they'd kill us if they got the chance."

"Because you were attacking their villages . . ."

"No reason to get huffy about it," I say. "And besides, they would also sometimes attack us if we were riding through the wilderness."

"Where they live."

"Or as some people would say, where they infest."

"But you never said that."

"No, never. But your question is one we used to talk about sometimes: if we rescued some orc babies and brought them back to a city, could they be trained to not be evil? We asked that question because sometimes when we would raid a village we would find human children who had been kidnapped by orcs, and in the games they were always evil."

I see the orc swallow hard.

But he asked for it. I never wanted to have this conversation. He forced me into it, and now he can damn well listen. I say, "Even if raised in a lawful good society by lawful good step-parents, attending lawful good boarding schools, the best you could hope for was that the adopted orc was not fully evil, but only partly so. And of course the adopted orcs had no creativity. But if

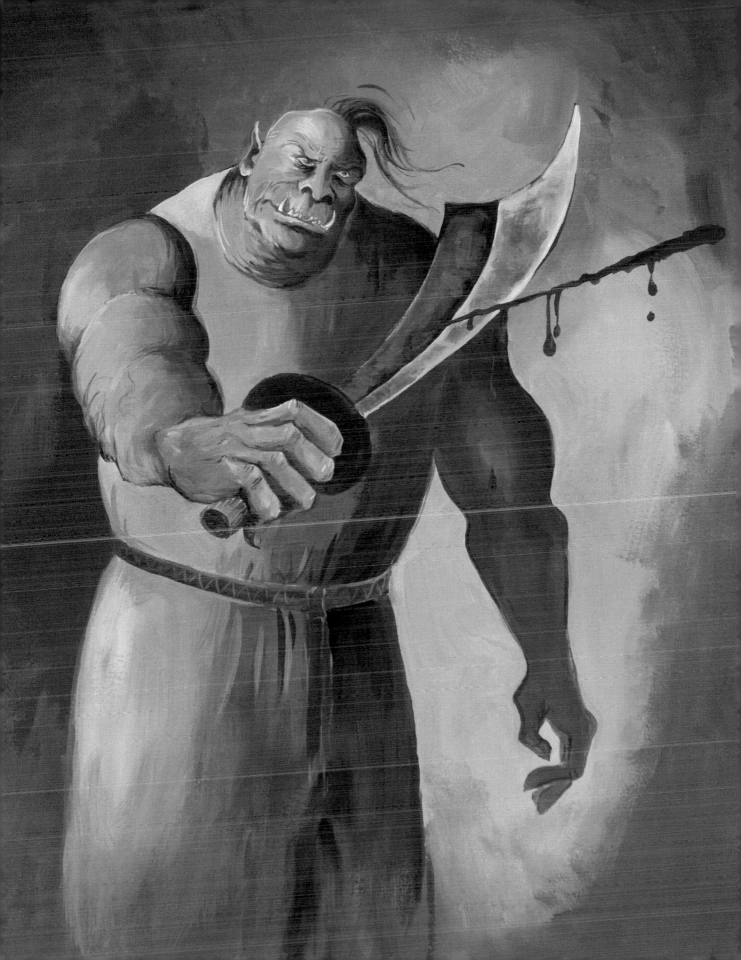

properly trained and disciplined they could sometimes make reliable servants, so long as you always watched over them. Lazy buggers, they were."

I remember that my favorite fighter was able to amass enough treasure and to clear out the monsters from enough land that he built a big castle and had an estate. He subdued enough orcs to work the fields and orchards and vineyards. They worked okay so long as you had decent fighters as foremen. I think the ratio of fighters to orcs was something like one per ten before productivity started to fall.

I'm positive that hearing this is going to make the orc mad, but it doesn't seem to.

The orc asks, "Did you know that Gary Gygax never interviewed any orcs?"

I have to laugh at this. I say, "Of course he didn't. There are a lot of monsters in that game. Do you think he interviewed a mummy and a griffon and a silver dragon? He wouldn't have time!"

The orc doesn't laugh. He says, "I don't know which is worse, to interview us and lie about us, or to not even bother and just presume we're evil from the get-go. I should have learned my lesson from talking to Tolkien."

There he goes, getting all self-righteous again. I ask, almost defiantly, "What lesson is that?"

"That my kind cannot talk to your kind. You really are irredeemable."

Almost faster than I can see, the orc pulls a knife out of his belt and draws it across my throat. I feel a rush of warm liquid covering my front, then a sharp pain where he drew the knife. I hear a rough whistling sound each time I breathe. My hands reach instinctively for my neck. I cannot think. I want to swing out at him, but he is standing a few feet away, watching me warily. I begin to sway. I think to say, but can't get the sound past my severed windpipe, "They were right. You are evil."

Leprechaun

ILLUSTRATIONS BY CHERISE CLARK

ame?"

"Lucky."

"That your real name, the one your parents gave you?" The police clerk's voice is like a cheese grater on skin, painful, and guaranteed to rub the wrong way. "What sort of parents name their kid Lucky?"

"Mine."

"Last name?"

"Just Lucky."

The police clerk calls to an officer behind him, "Ray, we got a drunk . . ." He turns back to Lucky, says, "You a dwarf or a midget? I never can remember which is which."

"I'm a leprechaun. And I'm not drunk."

The clerk says, "Whatever. Ray, we got a drunk small person."

"What do you want me to do about it? Get him some Lucky Charms?" Ray asks.

The clerk looks at the clock. Why does this always happen fifteen minutes before shift change? He looks at Lucky. "You got to have a last name. Otherwise I can't fill out your complaint."

Lucky stares at him.

The clerk says, "Okay, how's this? First name: Lucky. Middle name: The. Last Name: Leprechaun. Now, ready to go on?"

Ray says, "Hey, you really a leprechaun?"

"No, he's just drunk," says the clerk.

Ray puts his hands on his hips, spreads his legs, and says, "Do a leprechaun trick."

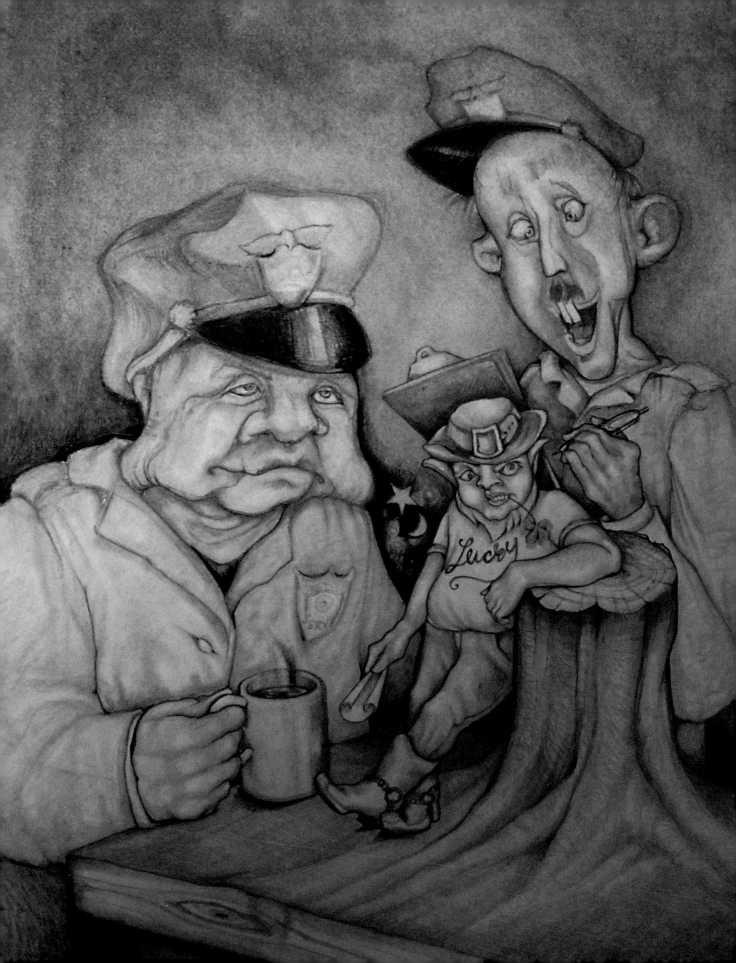

The clerk asks, "What's a leprechaun trick?"

"How would I know? I never seen a leprechaun before. My granny, God rest her soul, said there used to be lots of them."

"You believe that crap?"

"Now you gonna talk about my granny?" The two cops look at each other a moment.

Ray continues, "You go your whole life, you never see a leprechaun, then you see one, you got to ask for a trick."

The clerk says to Lucky, "Age."

"None of your business."

"Quit bustin' my chops. You want me to fill out the complaint?"

"358 years."

"The oldest leprechaun I ever seen," says Ray.

"You never seen a leprechaun," the clerk responds.

"I'm just sayin."

"He's lyin' anyway. Leprechauns always lie."

"I thought you didn't believe in . . ."

The clerk turns to Lucky. "Okay, Mr. Leprechaun. We have your name and age. Now we need your address."

"I live in the magic portal at the edge of . . ."

The clerk says, "I didn't catch the street number."

Lucky says, "Look, I want to report a theft. Someone stole my—"

"No, you look. I need your street address. I do not need magic portals."

Lucky pulls a paper from his pocket, shows it to the two men. "Can you read this?"

The two men look at the writing, which is like nothing they've seen before. They shake their heads.

"It's a very important message," Lucky says.

The clerk looks at Ray, then holds an imaginary mug of beer to his mouth and moves his Adam's apple in the universal "he's soused" gesture. "Get the keys, we'll pop him in the drunk tank, let him sleep it off."

Because the clerk and Ray are looking at each other, they miss their only chance to see a leprechaun trick, as Lucky disappears, with the sound of a small whip cracking and a puff of sweet-smelling smoke.

"He left fast," says Ray.

The clerk responds, "So, was he a midget or a dwarf? I can never remember which is which."

Lucky sits in a confessional. It's dark, and confining, even for someone as small as he. Lucky thinks it feels like a grave, although he wouldn't really know.

The priest's voice is slow, as though his internal metronome is set to largo. "How long has it been since your last confession?"

"Never. I'm not Catholic. I'm not Christian. For that matter, I'm not human."

A pause. "What are you then?"

"A leprechaun."

A long silence.

"God will still help you. So . . . what is your sin?"

"I don't believe in sin."

"Then why do you want to confess?"

Lucky is silent for a moment. "It's very embarrassing."

"Nothing is embarrassing to our Lord Jesus Christ."

"It's not him I'm worried about embarrassing. It's me."

"So, what did you do?"

"It's what someone else did."

"You want to confess someone else's sin?"

"He stole my pot of gold."

"Who?"

"That's why I came to you. So you could ask God to help me find it. I already asked the police, but they were bloody useless, like always."

"You want God to find your pot of gold?"

"He's supposed to be omniscient, right? You're his representative. I put in a request to you, you put in a request to him, he tells you where I find the thief, you tell me, I get my pot of gold, and the thief gets something to think about."

A deep sigh from the other side of the confessional. "What is your confession?"

"Someone took my pot of gold, and I didn't turn him into a statue."

"Ah, you let the thief go because through the grace of Jesus Christ our Lord and Savior you realized the thief's life was worth more than mere gold."

"No, I messed up my spell."

More silence.

"I hadn't been practicing enough. That's my sin. So my question is, how many Hail Marys

does it take to get the Big Man's ear?

"That's not how God works."

"Then what use is he?"

"Why are you making up these stories?"

"Are my stories harder to believe than stories about an omniscient God who won't even help me find my pot of gold?"

"My son. I sense you are troubled. Perhaps you need a different sort of help . . ."

Lucky doesn't even bother to show the priest the paper, but disappears, with the same cracking sound and the same sweet smell.

oo

The therapist's office is done up in pastel, from the off-white lampshade to the lilac walls to the two comfy chairs, one butterscotch and one caramel, to the seafoam plastic flowers in the powder blue vase on the pale taupe coffee table. Lucky presumes it's supposed to make him feel safe, but he feels more like he's died and gone to a hotel.

The therapist asks, "How does it feel, right now, in this moment, to tell me that someone stole your pot of gold?"

"It makes me angry."

"Ah, that's good. That's a start. Would you like me to give you a pillow you can hit?" The pillow cover is lavender.

"No, I want you to help me find the thief and give him what-for, and I want you to help me find my pot of gold."

"You don't want to express your rage?"

"Not now. When I find him."

"Just a tiny bit? It'll feel good."

No response.

The therapist asks, "Do you mind, then, if I hit the pillow a couple of times?"

Lucky just looks at him.

Suddenly the therapist says, "How does it feel to have parents who named you Lucky? Was it horrible? Was it embarrassing?"

Few humans have ever seen a leprechaun. Even fewer have seen a leprechaun stunned speechless.

The therapist continues, "Are you sure your primary concern is with a pot of gold? Are you sure the theft of gold isn't representative of something else that happened when you were younger, something deeper, darker, scarier?"

"I want my pot of gold back!"

"Of course you do, Little Lucky. You want your precious pot of gold, the precious pot of gold that was taken from you in the dark night when you were a little leprechaun, that dark night when The Bad Thing Happened to you." He holds out the pillow toward Lucky.

Lucky shakes his head.

"Did the Bad Person say you were The Lucky One? Is that how you got your name, Little Lucky? Did you get special attention? Did it make you scared?"

Lucky pulls the piece of paper out of his pocket, holds it toward the therapist, asks, "Can you read this?"

The therapist looks at it. "Is this the secret message from your little leprechaun inside you, the secret message you've been trying to tell for all these years? The secret message that gives you nightmares when you try to sleep, that makes you scared both day and night?"

"No."

The therapist says, "Of course you would say that. This message must be very scary to be written in such a strange and mysterious language." He looks intently, caringly, imploringly at Lucky. "But you know, Little Lucky, it's not as important whether I can read this note as it is that you learn to understand it, that you learn the deep and scary secret of 'who stole my pot of gold.' Even more important is that you only understand this message when you are ready, and when you are strong enough, and when you no longer deny that what we're really talking about is something that happened to you long ago. When you understand this, the message will be clear."

"Oh, for crying out loud," says Lucky. He puts the paper in his pocket, and disappears.

The therapist nods thoughtfully and says, "He clearly wasn't ready to face his issues."

∞

Lucky next goes to hire a private investigator. The office is small and dark, as though the broken dreams of those who've come here have sucked the life and light right out of the air.

Lucky lays out what happened.

The investigator listens carefully, then asks, "Can you tell me anything about the thief?"

"Well, he was a human."

The investigator laughs, a big horsey laugh, like if Mr. Ed saw a kangaroo kick a jockey in the balls. Then he says, "Of course it was a human! Who else would steal gold? A duck wouldn't steal gold. A bunny wouldn't steal gold." He laughs again: another jockey is down.

Lucky asks, "Is now the time you start your detection?"

"Now's the time we discuss you paying me."

"But I told you, my pot of gold is gone. I was hoping you could do this on contingency."

Another laugh, this one not horsey, but sharp and dismissive. He says, "Money up front."

"I haven't got any."

The investigator gives Lucky the sort of tight, triumphant smile you see on a parking patrol officer sliding a ticket under your wiper as you run to your car, keys in your hand. He says, "Ah, now I will give you some detection for free. Either a) you are a leprechaun as you say, in which case I will not work on spec, since leprechauns are known to lie; or b) you are not a leprechaun, since leprechauns don't exist (you see, I've already done some detective work!), but you are claiming to be one, in which case I will not work on commission, since you are already lying to me. Ipso facto, I need to get paid up front. Free consultation time is over."

Lucky asks, "Kind sir, will you please look at this piece of paper?"

The detective does. "What do you want me to do with this?"

"Read it."

"I can't."

"I didn't think so." And with that Lucky and his paper disappear.

○○

Lucky tries many ways to get help finding his pot of gold. Most people ignore him. Some don't see him at all. A few insult him. None can read the paper.

Finally he sees a young girl. He says hello.

She does, too.

He asks her age.

She says ten.

He tells her his name.

"My name is Lucy! If we add a K we're just the same!"

"I'm a leprechaun," he says.

"I've always wanted to see a leprechaun. I always knew they existed. I just knew it!"

He tells her that his pot of gold has been stolen.

She thinks very seriously, then says, "I don't think I can find the thief, because I don't know what a thief looks like. But I do know what a pot looks like, and I can imagine one full of gold".

She walks around, looking under cars on the street, under bushes. She asks if the pot has a handle, and he says it does. Then she looks around the nearby trees, as though it might be hanging from a bough. She looks and looks, but cannot find one. She asks if she should get her two brothers and her mother and father to help look.

Lucky says, "Thank you very much, but I don't think that will be necessary."

He pulls the paper out of his pocket, shows it to her, asks if she can read it.

She cannot make out a word.

"Let's try this." He waves his hand over it and in front of her eyes it translates to English. It is a recipe. He reads it aloud to her. It says she needs to pluck one of her own hairs, and prick her finger to extract a drop of her own blood, and combine them with three certain herbs we won't mention here (We wouldn't want to reveal the recipe just to anyone, now would we? You'd have to help a leprechaun in order to be able to read it yourself) and mix it all with water and then drink it.

Then if any others—and Lucky stresses "any others"—try to harm her in any way, she will be invulnerable for as long as the potion lasts. He tells her she could even walk up to a zombie and

say, "Give us a kiss, luv" and the zombie still wouldn't bother her.

This makes her laugh and laugh.

He gives her the proper herbs and tells her to make five doses, one for each member of her family—using each one's hair and blood for his or her potion—and without fail to do this tonight and to get all of them to drink it.

<div align="center">◑◐</div>

That night Lucky sits in his home, behind the magic portal. His pot of gold sits behind him. People were right when they said he was lying. It was never lost. But he wasn't lying when he said that the message was important.

It's dark now, with only a hint of moonlight reflecting off the tall grass on the other side of the portal, and the other side of the stream by the portal. And he sees that they are coming. For a long while now he has known that what humans call monsters are going to overrun this village. He'd thought he'd see if anyone in the village was worth saving. Those deserving of help should be willing to help others, too.

Tonight there will be one family of humans in the community safe from the so-called monsters, and there will be many families of humans who end up dead.

They should have treated Lucky differently, huh?

The Delivery

ILLUSTRATIONS BY CHERISE CLARK

First of all, let me settle the question of storks. They've got nothing to do with it. Sometimes we use them for local transfers, but their reputation is almost entirely undeserved. We're the ones who deliver the goods.

Second, there's the question of mistakes. Missing the date isn't much of a problem, because if there's a backlog we can always deliver in a day or two when things slow down. It's more serious when addresses are switched, since it can make for unpleasant surprises. Even these mistakes aren't usually a big deal, because most of the recipients are so smitten by the new arrival that they don't sweat the details. Of course, I could tell you some stories about getting the species wrong. I don't want to think about the trouble that type of mistake brings about.

But there's a facet of the job that's caused me more distress than all these problems combined: conscription. Usually I like this job, and I've been able to live with even the hard cases. But I have to tell you, because of conscription, I'm thinking about resigning.

Before I go any further, I need to tell you how the system works. About nine months before a kid is supposed to be delivered we get an order form, filled out in triplicate. Nine months, that is, if the kid is a human. For elephants it's longer, for rabbits or gerbils it's incredibly short. Nobody likes those assignments—too much running around, no time to rest. All the rabbits seem to want to be delivered yesterday, you know what I mean?

So we get an order for a delivery, and we put up notices to see if anybody volunteers to be born. Prime positions usually draw a lot of interest from the babies. We have babies lining up to be blue whales, for example, and grizzly bears, or once in a while humans, especially tribal peoples. Positions are assigned on a first-come, first-served basis.

Usually. That's true for the good positions, and also the trendy ones. A few years ago salmon were hot, but now with the dams we don't get so many volunteers. Bad positions, though, we have to fill by conscription. Lab rats, for example, or factory chickens. You've never truly heard a baby squeal with terror until you've seen what happens when someone posts an order for a batch of factory farm pigs. Sometimes it's enough to break your heart. But we've got a job to do.

As soon as the positions are filled, the babies begin intense counseling to prepare them for their new lives. The counseling is both emotional, to prepare them for the life of a dung beetle or a sea horse, and physical, to shape them into what they'll be. These forms of counseling work closely together. It simply would not do to prepare someone emotionally to be a rattlesnake and physically to be a human (or vice versa), and then drop this person onto an unsuspecting family, although this happens more often than many of us want to admit.

At the end of the training period, mammal babies are delivered to the bodies of their usually jubilant mothers. Or in the case of plants, they're scattered near their parent, also jubilant. And most fish are delivered straight to the spawning bed. By the time they've finished counseling and are ready for delivery, babies are excited to start their lives. Even among the conscripts there is at least some level of anticipation, if not eagerness, for the next part of their journey.

Which brings me to my last case. The baby absolutely did not want to be delivered. I didn't understand it. What could be so bad? He was a human, for crying out loud, not a rabbit headed to a vivisection lab.

Here's how it started: I got the order about nine months ago, and didn't think much about it. The parents were an older couple, remarkably old, in fact. But other than that there was nothing noteworthy about it. So I forgot about it until about a month before delivery.

Most of us try to check on our charges before the big jump, as we call it. It reassures them, and reassures us, too, that things are progressing well. Once in a while we get a bad seed, so to speak, and it's always helpful to know we've got trouble coming down the pike. When I checked on this human baby eight months after the order was submitted I saw right away that he had a haunted look, like the one carried by animals destined for a lab, and by vegetables marked for intensive farming. We see it, too, among humans born to the poorest of the poor, especially little girls. I try not to think about that, and because of my seniority I've been allowed to excuse myself from those deliveries.

On pick up day he was no better. He still looked spooked. I picked him up—the phrase 'picked up' being something of a euphemism.

It's hard to explain what it is exactly that we carry. The babies' bodies are already inside the bodies of the mothers. What we bring is the babies' psychic energy, made by the Woman in

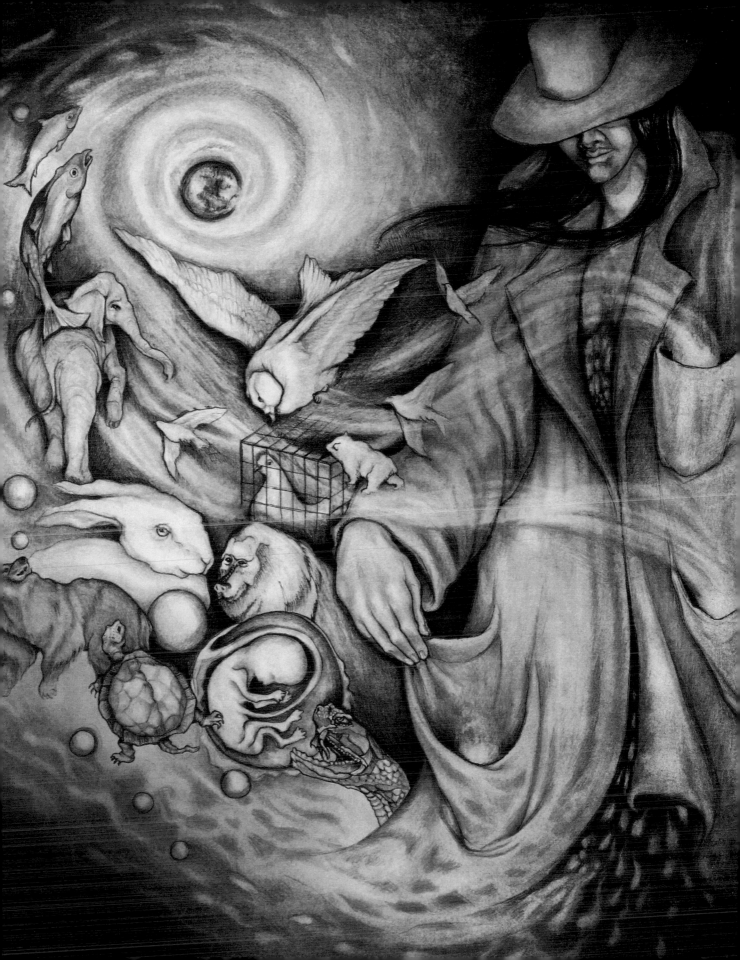

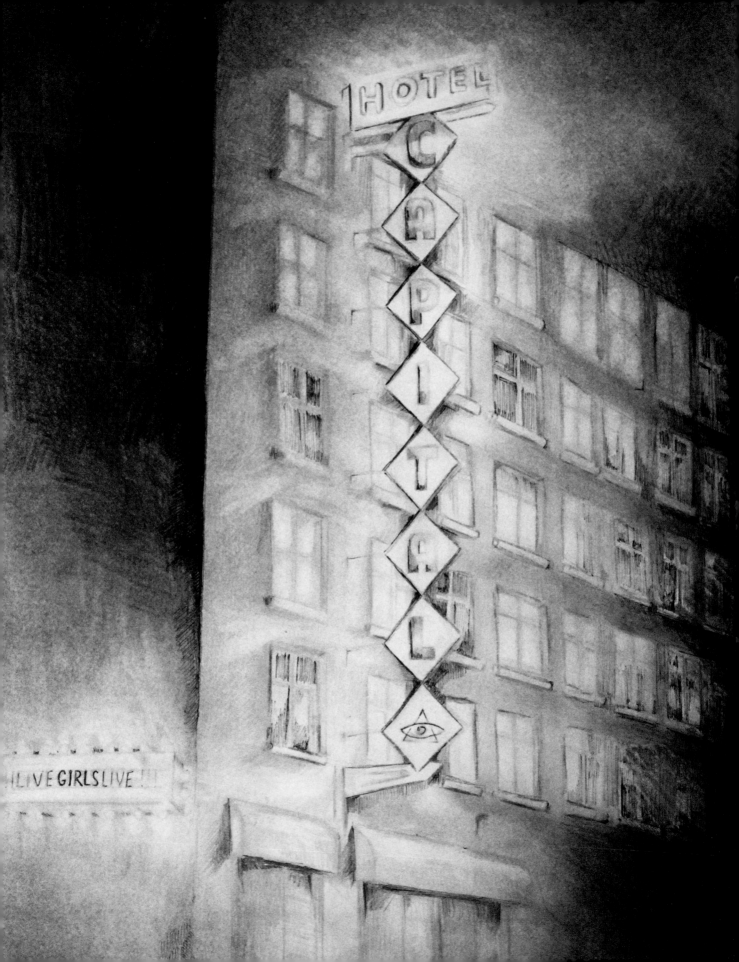

Charge. We carry it in the deep pockets of our coats. When we're making several deliveries in the same neighborhood, such as a many bunches of baby songbirds, we put them in different pockets. Sometimes for fun we put them all in one pocket and let them have a final pre-birthday bash.

I carried the baby boy in his own pocket. He didn't talk much. Sometimes I talk with the babies about their dreams. I might ask, "What are you going to do as a child? What's it going to be like to grow up?" In the case of those whose futures will be unspeakably bleak, I usually respect the unspeakable part, and keep my mouth shut. Sometimes I'll stroke them to let them know someone cares at least a little bit.

I asked the baby a few questions. No matter what I asked, he remained huddled in the corner of my pocket. Eventually I stopped talking and stayed quiet for the rest of the journey.

We approached the delivery site. It was a cold night, and the neighborhood was unwelcoming. I found the right building, and then I, too, began to feel a little spooked. It was one of those downtown hotels that crowd every major city, hotels with names like "The Merlin," or "The St. Charles," hotels that have one bathroom at the end of the hall, and greenish wallpaper peeling from the walls, halls that always seem to stink of urine, alcohol, and illness.

But I composed myself and said, "How bad can it be? Your momma loves you."

I always say that to the lab animals. At least they get that brief solace before the experiments start. I thought that might help here, but it didn't seem to.

His parents were on the seventh floor. I floated up the stairs and down the hall. I passed through the door. The room was spare and cold. It was so cold. The window was open, and were it not proscribed I would have shut it myself. A thin wisp of snow had blown in to cover a small table by the window. Snow had blown onto the floor. The room was lit by a single lamp, high in a corner.

The mother was in a chair. She was in her early fifties. Her hair was gray, her face lined and tired. Clearly the delivery had been difficult for her. Her head was back and her mouth was wide open, as though she had fallen asleep mid-birth. Or maybe even before. Her legs were spread, and her nightgown was hitched up to her waist. Blood pooled at her feet. This would not do. It's not precisely within my job description, but I decided to wake her and help her into bed, next to her husband.

Seeing him asleep, too, I felt a sudden flurry of anger: how could he let her remain like this?

I would put some covers over her. If necessary I would go to another room to get more blankets. And damned if I wasn't going to shut the window.

I touched her on the shoulder. She didn't move. This woman was far too old to be giving birth. I gently pulled down her nightgown, then took hold of her arm to make a cradle for her new child. Her arm was as cold as the rest of the room.

Suddenly I was cold, too. I put the baby back in my pocket and went to the window. I shut it. I leaned on the table. Then I walked to the bed. The man was on his back. His face, too, was tired and lined.

"Poppa," I said, "I know you've lost someone important to you, but you've got to wake up now to welcome your new son." I took the still silent baby out of my pocket and laid him on the man's chest, in the crook of his arm. The man didn't move.

This was not good. I touched his cheek. It was as cold as the table.

Still the baby didn't cry. He didn't make a sound. Never before had I been tempted to bring someone back home with me. Not even veal calves, who have at least the licking of their mothers' tongues to warm them before they're carted away. Not even baby praying mantises about to be eaten by their moments-older siblings. Not even the very last dodo bird (whom I personally delivered), who would spend the last years of her life lonely and afraid, looking for a companion. She, too, had at least a few moments of love when she was young.

I put the baby back in my pocket, and thought about the reprimands I'd hear when I got home. "Don't be so sentimental," they'd insist. "What would happen if everyone acted this way? Do you think we want every pink-nosed baby lab rat running around here? Every baby has a job to do down there. You take him back right now."

"I'll find him another home," I would say.

"That will be quite the surprise for some woman, don't you think?"

I thought of all the forms I'd have to fill out in triplicate. I thought of my four other deliveries today—a twin set of bighorn sheep, a pygmy hippo, a human girl to a poor yet delightful family, and a whole raft of baby honeybees. So much work to do. And another busy day tomorrow. I told myself I couldn't afford the hassle.

So often I'm rewarded by the joy and love I get to witness—to be a part of. Just tonight, the mother sheep, the hippo, the humans, the queen bee and all the babies' sisters. Births. So much life. It's all so wonderful.

But there are times I can't take it.

I took the baby out of my pocket and laid him to rest on his father's chest. He didn't cry. He didn't wail. He just looked at me with his big eyes, begging me to take him with me.

I stroked his cheek, and turned away.

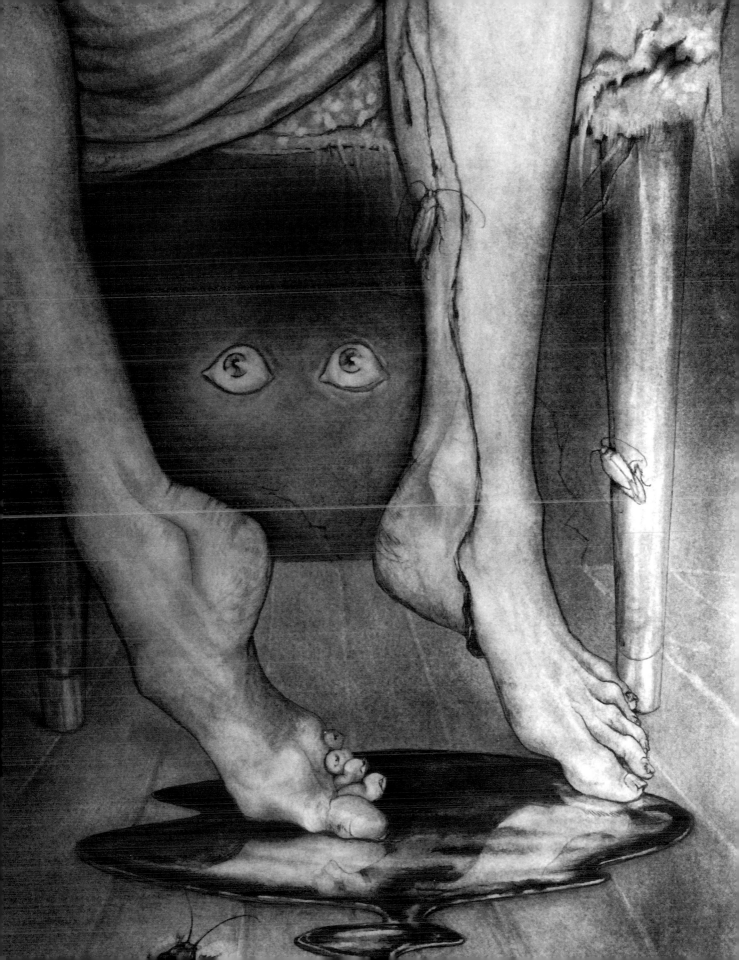

Troll, Part III

ILLUSTRATIONS BY KYLE DANLEY

The solution, when it came, was so simple it inspired the female troll to sing a song. The song was, given the simplicity of the solution, extremely complex, for reasons that are still incomprehensible to me. The solution came in the form of advice given by a rat who, going by his looks, had recently been mucking about in some automobile's engine compartment. Engine insulation clung in patches to his patchy fur, and he carried a short length of insulated electrical wire dangling from his lip like a cigar. He said, "From an ignition system." Then he gave his advice.

Of course, to me, it didn't sound like "From an ignition system," and it didn't sound like advice. It sounded like a bunch of squeaks.

When the female troll heard this advice she sang her complex song. And then we waited.

She later got confirmation of the advice from a fire. The troll wanted me to make sure when I told you this that I made it clear to you that she didn't mean someone gave us the advice while we were sitting by a fire, but rather that the fire gave the advice. Once again, it didn't sound like advice to me. It sounded like a bunch of crackles and a few sighs.

She asked me to drive her to see her sweetie. I told her I'd be glad to.

The first time she prepared to get in the back of my truck, she blanched. I'd never seen a pale troll before. Of course, only recently I'd never seen a troll at all, so I guess this was no surprise.

After several false starts and much encouragement, she crawled into the bed. I covered her with a tarp, to which she clung tightly. I started the truck and began to drive. I soon heard a keening from the back, like the howl of a frightened dog. I figured she'd get over it.

We got to the bridge where I first met the other troll, and pulled off to the side. I made sure no cars were coming then told her she could get out. She did, and quickly disappeared under the

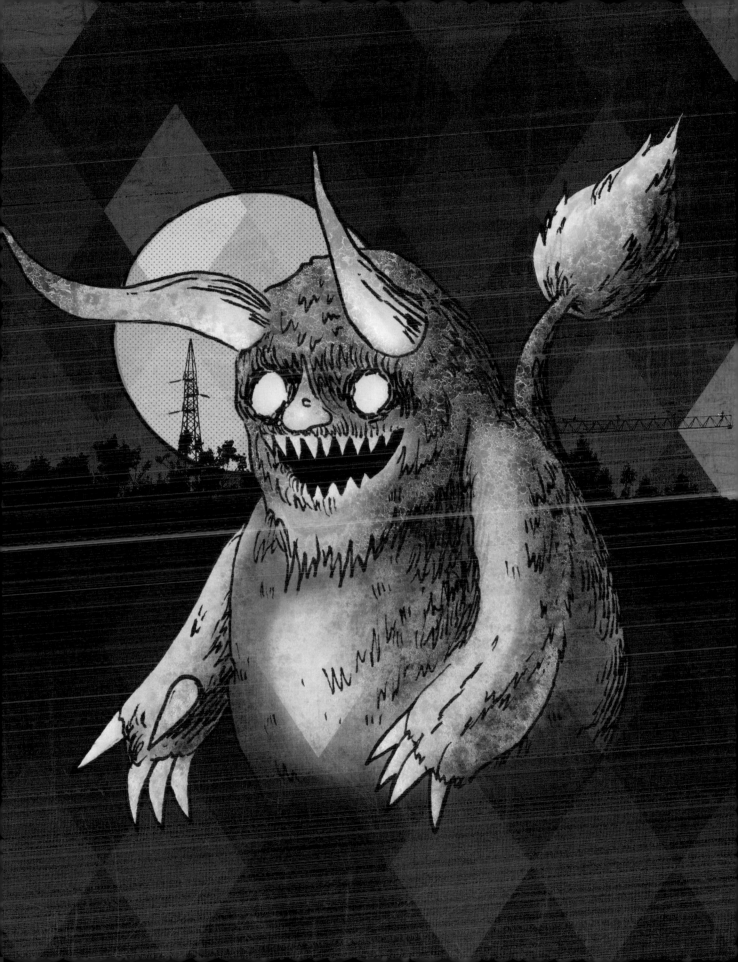

bridge. I took two steps to follow her and make sure they were okay, then realized I might not, at that moment, be welcome. I knew they were both deeply grateful to me, but I also remembered how sharp were their teeth.

I came back two days later. I had no idea how long troll sex takes, and I saw no reason to underestimate.

When I got there, they were sitting next to each other, smiling their wide-mouthed sharp-teethed smiles, and laughing their silent wide-mouthed sharp-teethed laughs.

They said they would be grateful if I would drive one of them around to a long list of places.

I said, "I will if I can." I was wondering how this gratitude would manifest. They didn't use cash, so they couldn't even pay for gas.

The male troll said, "We will take very good care of you."

I asked, "What does that mean?"

The female troll said, "It means we will take very good care of you."

The first drive was going to be about forty-five minutes. He wanted to go in her place—I wasn't sure why, because of what he'd said before about technology—but she refused to allow this.

They looked on their map, converted how they perceived directions to how they perceived I perceived directions, and finally were able to show me where they wanted me to take her.

We drove. This time her keening was much quieter, but it was still there.

When we got to the right bridge we repeated the procedure of me checking carefully for witnesses, then watching her disappear below the bridge. She had told me to wait about ten minutes, and then come down. Under no circumstances was I to come down sooner.

I didn't, thinking of those big sharp teeth.

I went under the bridge and saw a tiny fire, and that's about it. I moved close to it, hunkered down. I didn't say anything. I just kept looking around.

Then I heard the beginnings of a troll song. I looked in the direction of the song—it sounded extremely close—but couldn't see anything. I closed my eyes and listened. The longer I listened to the song, the more I felt a rage overtaking me. It possessed me. It consumed me, yet somehow left me more whole than before I began to feel it. I wanted to—needed to—let out this rage. I needed to aim it and let it fly like an arrow.

I began to pace back and forth next to the fire, beneath the bridge. I heard growling, and soon I realized the growls came from my own mouth, my own throat, from all over my body, from my heart.

And then the song ended. And so did the rage.

Or maybe it didn't. Just as that first troll song, of joy and longing and belonging, had forever changed me in ways I could not even hope to articulate, and just as each of the troll songs I had heard since had done; so too did this song change me. Having for the first time felt such a righteous rage, I knew I could never go back to who I was before.

And then I saw the trolls. The two of them. All along they had been right next to me, but they had been, as they'd had to do for so long, hiding. And now they weren't.

I said, "I will drive you wherever you want to go. I am with you now."

Neither smiled. The new troll did not move. The female troll slightly nodded.

We walked back to the truck. When we got close to the road I went first to make sure no one was around. Then I motioned for her to come and get in. As she did, she said, "Every time I get in this machine, I feel a part of myself die."

I thought, but did not say, "Funny, I never feel a thing"

I drove. She keened. We met another troll, and then another, and then another. Others, too, now, others I never knew existed. Orcs and goblins and ghosts and werewolves. Fairies, pixies, sprites. Ogres and salamanders and a couple of dragons. She didn't tell me what she was saying to them, and I didn't ask. Even though I was with her, each of them looked at me warily before more or less seeming to accept me.

We met others, too. She talked to rivers and mountains and rocks and toadstools and elk and bears and trees and little pieces of soil. She talked to fires. She even talked to a few humans. That made me feel a little jealous, but only a little. She was, I presumed, telling all of them of the plan she'd heard from the rat and from the fire.

All of this took months. I'd quit my job, and was using my savings to eat and for gas. I knew this was on one level foolish, but on another level, how many people have been entrusted with a mission by a troll? At the end of my life would I rather look back and say I kept working at my job, which I didn't really like anyway, or that I had helped some trolls do what they needed to do to protect their homes?

I could tell the car trips were weakening her. Often I'd drive her back to the stream that was her home. She would stay there a few days to recover, and then we would begin traveling again. She was always pale. Even when she visited her male friend she got no flush in her cheeks.

One day, after she'd been at home for about a week, and after I'd taken her to visit the male troll, the one I first met so long ago, I finally asked, "What's the point of all of this? How is all of this driving around going to save your home from being destroyed?"

She told me the plan.

"You can't do that!" I said.

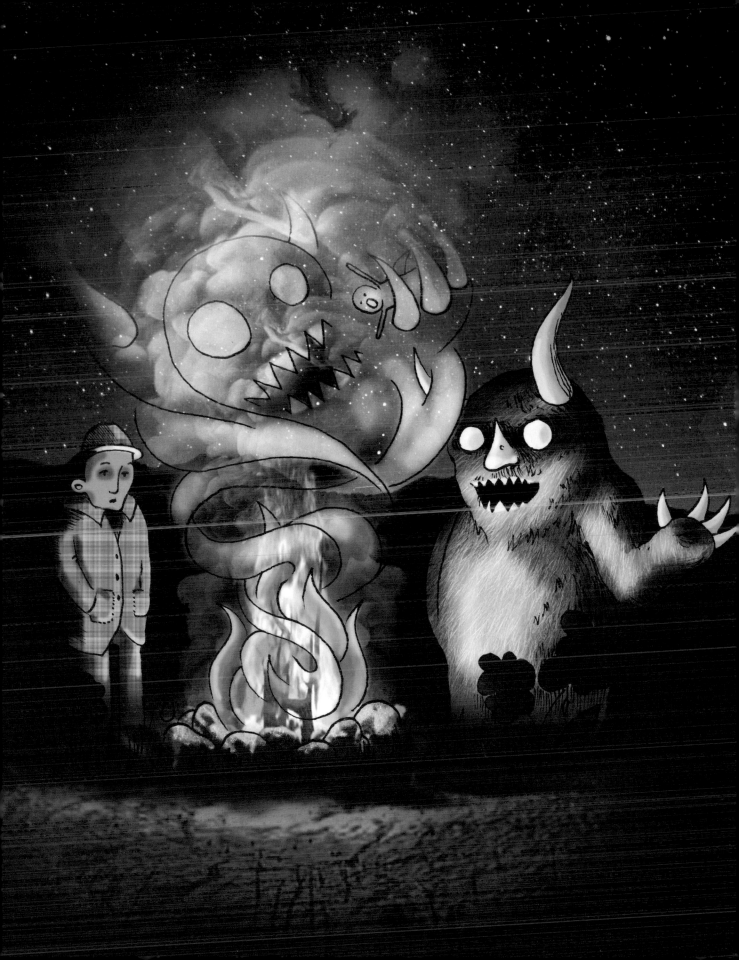

"What else are we supposed to do? Should we trolls file a lawsuit? Will that help?"

The male troll asked, "Should we appeal to their sense of 'humanity'? And isn't that word about as bigoted and wrong as you can get?"

"Maybe if you talk with them . . ." I trailed off. It sounded stupid even to me.

"They won't listen. We've tried."

I thought a moment, then said, "What about me?"

"We told you that we would take care of you."

"When does this start?"

"Soon, very soon."

"And how did you get this from what the rat said?"

The male troll laughed that wide-mouthed laugh, only by now I could read him well enough to know that this particular laugh was as mirthless as it is possible to be.

The female troll said, "The rat said we should remember we are animals, and we should use our teeth and claws."

"And the fire?"

"The fire said we should consume them all, leave nothing behind. What of theirs we do not eat we must burn. Nothing must remain of them. They have destroyed too much, and will not stop."

With this the two trolls began again to sing. This song had parts of all of their other songs, and it was also much more. I felt the joy of connection of that first song, and I felt mourning, and I felt rage, and I felt a fire start to burn inside, a fire that I knew would carry me through the coming battles, carry me along with the trolls and orcs and pixies and rivers and rocks and trees and the rest of the living, carry me through till the last of the monsters—the real monsters, the monsters who were already killing everything and everyone who lived—had been once and for all destroyed.

STORY ORIGINS

Monsters

"Monsters" is the core story of this book. I wrote it at the same time a friend was desperately and unsuccessfully trying to stop monsters from poisoning a prairie dog village in Colorado. The description of what happens to the poisoned prairie dogs is accurate.

Favorite bits: the poisoned prairie dogs break my heart, as do the caged hens, and of course the songbird.

The work of monsters. It's all so heartbreaking.

Demon Spawn

It is unseemly for an author to favor one story over another he or she has written—just as it is for parents to do the same with their children. But I do so love the tone of this story, and I really enjoy the wry intelligence of the protagonist. I also very much like her relationship with her family.

The story had its genesis in the horror that is high school. I remember the valedictorian of my high school class saying we would look back on these days as the happiest of our lives, and me thinking, "If that's the case, I should kill myself right now." High school was a nightmare. This is true for almost everyone I have ever met.

Meanwhile, I wanted to write a story from the perspective of a demon. I put those two together, and wondered what it would be like to be a demon in a school full of humans. The protagonist arrived, and told me her story.

Favorite bits: I love the line where she says that no matter what type of being they are, parents don't understand anything. I've read this story probably thirty times now, and that line still makes me chuckle. And the line about how the admission price to heaven is too high, and you have to pay for individual rides anyway. And of course the heaven/hell inversion. But my favorite part of the story is the stage scene, where she feels how profoundly her family loves her. I cried when she told me that part.

Killer

For me the first line is the hardest and most important part of a piece of writing. It sets the tone and scope for everything that follows. The rest of the work is filling in details. Sometimes that first line remains the first line of the final draft, and sometimes, like scaffolding to help construction, it is removed when the building is done. This time it stayed.

This story owes its first line to Ray Bradbury's *Fahrenheit 451*, which has, I think, one of the best opening lines in fiction: "It was a pleasure to burn." I'm sure you can see where I got my opening. What is that cliché about writing? "Immature poets imitate; mature poets steal."

❖❖

The first line led to the question, how is it a pleasure to kill? That line led to the next one, and that to the one after. Just filling in details.

❖❖

With this story I was trying to describe this culture's death urge, its urge to destroy. I was trying to meld the sexual sadism and necrophilia central to patriarchy's core violation imperative with its most modern manifestation, the obsession with machines, and the replacement of a living planet with machinery.

Favorite bits: the last description, that starts with the sound of electricity coursing through high-tension wires.

Also, I love how the descriptions by the Killer still work when you understand that the Killer is technological "progress."

Werecreature

I remember when I was a kid I often stayed up late on Saturday nights to watch Creature Features, a double feature of old horror movies. They scared me witless. There was, for example, the "spikes coming out of a binocular's eyepieces" scene in *Horrors of the Black Museum* (filmed in "hypnovision") which made me leery of binoculars for many years. (That movie also had a "guillotine secretly installed over the head of the bed" scene that made carefully checking the ceiling part of my bedtime routine.)

Another film that affected me was *The Wolf Man*. This one didn't so much scare me as make me sad, at Lon Chaney Junior's brilliant portrayal (remember, I was a kid) of emotional agony over what he had done in a wolf-state.

So, the germ of this story is this question: if wolves wanted to tell a scary story of a werecreature, what story would they tell? From there it unfolded easily.

Please note: all of the ways the werehuman kills wolves in this story are real ways industrialized humans kill wolves.

Favorite bits: I think the beginning is very strong, and it was interesting to do the math to figure out, in this case, how long it takes a bullet to penetrate skin.

I enjoyed following the process of the werecreature becoming accustomed to his transformation.

My use of the "confessional" format is an homage to its frequent use in those movies I loved (and was terrified by) as a child.

Skeleton

I began "Skeleton" knowing three things. The first was that I could clearly hear the narrator's voice. The second was that his friend's name was Widgie. The third was that I hate amusement parks, and especially hate this culture's attempt to turn the entire planet into one. Beyond that I knew nothing, until the protagonist began telling his story.

∘∘

It ends up that's not true, and the realization it's not true taught me something about how stories are written. Or perhaps about memory, or perhaps about what we believe happened versus what really happened.

When I wrote the first paragraph above, I was, to my knowledge, telling the truth.

But then I came across some notes I assembled when this story was first conceived, and learned that paragraph isn't the whole story. The notes contained a letter written to me by a very smart woman analyzing anorexia and what it reveals about this culture's hatred of women.

The friend wrote, "I think the keys are: I don't need food or other people; only I control what happens to me; I can show myself the extent to which I am in control by literally controlling my life; I am very in control of my own life because I have partially convinced myself that I can live without eating; no one can hurt me; only I can ultimately hurt me.

"Civilized religion tells us we are really alive when we are dead: i.e. when all physicality is gone.

"I am trying to look how I feel: I feel like no one.

"Women are hated. They are told to hate themselves. In a sense, it feels more honest to act out the hatred completely.

"We are told me must be pure. Anorexia is the woman-hating quasi-religious rites of this

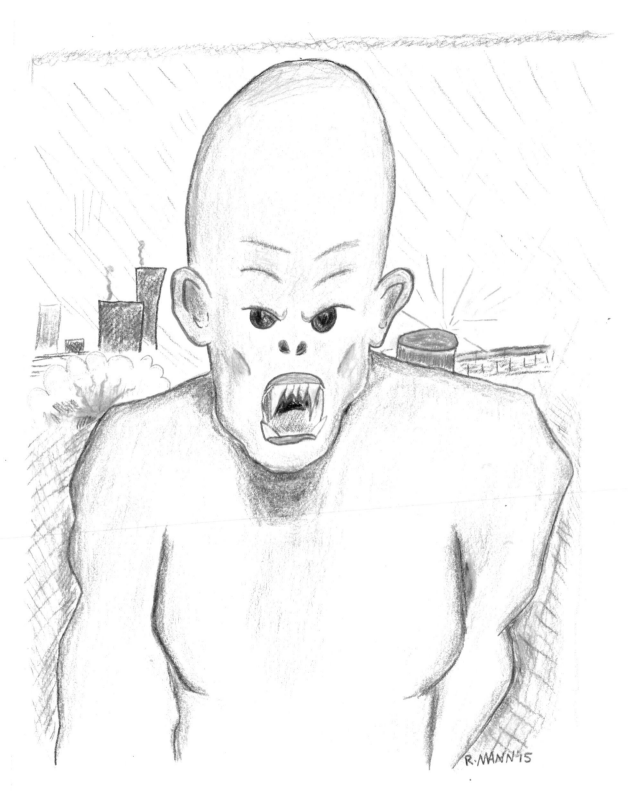

This drawing was created by Roxanne Mann, who survived a traumatic brain injury and still fights each day to help save this planet from monsters.

culture taken to their logical conclusions. As a woman, you are supposed to be 'barely there.' You might even cease to exist. This is of course what society wants.

"This culture hates life. It hates flesh, animals, physicality, bodies, reality, and so on, so when this all gets stripped away, we are left more 'pure.'

"Women are not supposed to be powerful. Womanly fat is gross. Food is gross. This culture is woman-hating and life-hating. It hates fundamental life processes."

◑◐

So what was the inspiration for this story? Hell if I know. For me that's the magic of writing. In goes a very good analysis of anorexia, a character named Widgie, and a hatred of amusement parks, and out comes this story.

◑◐

Favorite bits: I love the *Titanic* ride, which is of course about the murder of the planet, and I love the ride where Widgie pays to sit on a bed waiting for someone who will never show up.

Artist note: I put my name in to co-illustrate "Skeleton" because I liked the cool Dark Ages imagery in the story and lonely carnival weirdness. Also, I wondered if one could portray a skeleton as both feminine and sexualized: turns out you can (forgetting that the fashion industry has been doing it forever).

The Murdered Tree

The inspiration for this piece might be obvious if you're familiar with a certain children's book about a tree. I hate *The Giving Tree*. It seems a perfect description of an abusive relationship between an entitled piece of shit asshole and his co-dependent victim. Or rather it's a perfect description of the relationship from the perspective of the entitled piece of shit asshole, who thinks he is in a mutual relationship and that the other is gladly giving everything to him as he steals and steals and steals until he has killed the other.

I hate *The Giving Tree*.

The Giving Tree would be a great story if it acknowledged it was about abuse instead of presenting itself as a model of love and relationship. I've heard the argument made that it is in fact a description of abuse, but if so a lot of people have misunderstood it, since it has been promoted since its writing by many church and school groups as a message of love and a guide to relationships. And it's often read to grade school students in both public and private schools in the United States.

This all brings to mind the famous line by the psychiatrist R.D. Laing: "We are destroying ourselves by violence masquerading as love."

I needed to rewrite this story from the perspective of the victim. Somebody needed to do it.

Favorite bits: The end. I love how the forest fights back from the ground up. I only wish he would have been killed sooner. Perhaps I'll write it again, and this next time she'll throw him out of her branches and he'll fall on his head and die. Another time poisonous spiders can bite him. The time after bees will swarm all over him. Brambles will entangle him. Mushrooms like *Amanita phalloides* will offer themselves up to him as food, and an agonizing death. Bears will eat him. Dying trees will fall on him. Marshes, swamps, rivers and lakes will swallow him whole.

Those are all endings I can get behind.

Artist note by Sandra Ure Griffin: In my first illustration for "The Murdered Tree," the boy crowns himself king. The creation of this hierarchy estranges him from the interwoven web of existence around him. Lost now and disconnected from the Tree of Life, the boy (now a young man) is shown brutally dismembering the tree for his own use. My final illustration for the story shows the death of the boy/man, but depicts a ray of hope for the Tree of Life. I have seen sturdy sprouts growing forth from some of the "dead" stumps of clearcut forests. It reminds me of the tenacity of living, growing lifeforms—and the fact that all Life wants to live.

Ghost

When I was a kid and into my teens, I loved extremely short stories that ended with dramatic turnarounds. I read a lot of both Fredric Brown and O. Henry. Even though I haven't read either in decades, the Fredric Brown books formed an important enough part of my childhood to earn them a space in my box of memorabilia, along with my old baseball cards, a plastic "hot shot basketball champion" trophy I won in high school, and the ticket to my first rock concert (BTO and Heart).

So of course I wanted to include some stories shorter than 2,000 words. And this is one of them .This story began with a few questions: "What if there is a monotheistic God, but this God isn't essentially a super-powerful human? What if She is an aardvark, or a honeybee, or a mushroom? What if God is a tree?"

Favorite bits: I like when the protagonist complains about his son-in-law. Also, I had to think for a while about how to convey that the protagonist had been a logger and timber lobbyist. And I had fun imagining the scenarios where God is a cockroach, or perhaps a cow. Maybe if God were a lobster, St. Peter the Lobster would greet new human arrivals with a big pot of boiling water, and would say, "Time for dinner."

Troll

We've all heard that trolls are supposed to live under bridges. This made me wonder, what would be trolls' natural habitat? Prior to bridges, they must have lived somewhere. Since they live in forests, it must have been under downed trees. And with deforestation they, like many other creatures, have had to make do.

This led me to the questions, how would a human encounter a troll, and, how would that encounter go?

Favorite bits: I love that the trolls' songs are beautiful. And I love how the trolls are able to hide, though I hate the fact that they have to.

Also, the joke about being no longer fast but rather half-fast comes from a real incident. In eighth grade, I told my sister, who was in college, that in science we were learning about acid reactions. She convinced me that the teacher was remiss in not also teaching us about half-acid reactions and suggested I raise my hand next class period and insist we learn about these as well. I complied. The teacher stifled a grin, and invited me to talk to him after class. He asked where I'd heard of these. I told him my older sibling. He nodded and said, "Well, that explains everything."

Angel

"Angel" was originally supposed to be a comedy about a guardian angel who hates her job, so she intentionally kills people.

In that story, we'd first see her hatred of her job when the alarm woke her from a delicious dream and propelled her into yet another day of intense boredom guarding a random person from dangers that rarely materialized. She'd crack under the tedium, and knock off the person she was supposed to protect.

But when I wrote out the dream, it was filled with a longing so strong that it seemed clear this emotion had to be central to the story.

So I rethought the whole piece. Also, I realized that a guardian angel who whacks her clientele wouldn't last long before getting the sack. This led to the question, how could she be an angel, but still kill?

The answer came quickly: she could be an angel of death.

Then I started thinking about that friend we've all had—and goodness knows I've been this friend more than a few times—who is well-intentioned, but whose advice somehow always seems to yield terrible results. And I started thinking about our ability—and I'm certainly guilty of this, too—to interpret everything that happens as support for whatever preconceptions we have. So the guardian angel became an angel of death who believes she's a guardian angel, and

nothing can convince her otherwise. Everything that happens emerges from that misperception, and from the longing and loneliness she feels in that first dream. Of course no one wants to be friends with the angel of death, because as soon as the two of you hang out, you die.

I want to mention that the young woman who died heroically helping neighbors during the flu epidemic was my great aunt.

Favorite bits: the first time she gives bad advice that gets someone killed; nervous therapist Jesus; and the notion that the three Fates are spiders. Of course they are, spinning, spinning, spinning.

Vampire

For "Vampire" I wanted to describe a monstrous undead being who is completely out of touch with his body and with experiential reality, who hates and ignores physical reality, who believes he makes sense as he says things that are nonsensical, and who is completely incapable of self-reflection. I wanted to describe a character whose own soul is long since dead, and who now feeds on the souls of others.

In other words, I wanted to describe your typical philosophy graduate student, especially one steeped in postmodern theory.

I didn't have the courage to write about a full-blown philosopher, perhaps one with several books out. That would have been far too frightening, and I would have had to sell the book with a warning on the cover.

I thought having a philosophy graduate student interview a vampire would make a fun contest as to who would turn out to be the most narcissistic.

Favorite bits: I like the vampire bemoaning the fact that humans are no longer organic, but also enjoying the processed snacks. And of course the whole exploration of what it means to be undead.

Orc

Like so many other nerds back in the 1970s, I inhaled *The Lord of the Rings* and I played Dungeons and Dragons. Even though I wasn't very politicized, it still occurred to me that orcs were getting a bad rap. How was it, I wondered, that in D and D we adventurers could label ourselves as "lawful, good" as we systematically plundered our way across these imaginary worlds? We routinely killed every creature we saw, enriched ourselves on their booty, and felt good about doing it.

Gosh, have we ever heard of anyone else doing that?

This story was fairly easy to write. All I had to do was ask the orc what it was like to be him, and he was eager to talk.

I hope he likes how I portrayed him. I wouldn't want to end up on his list with Tolkien and Gygax.

Favorite bits: I love the orc's opinion of his interview by Tolkien, and his opinions of dwarves, elves, and hobbits. Sorry, I mean, "fucking hobbits."

Leprechaun

I modeled the plot of "Leprechaun" on fairy tales and other classic morality stories, in which a series of characters are presented with a test. Unbeknownst to them, if they fail the test, they die. If they pass, they receive a boon, in this case their lives.

Favorite bits: I love the line "The investigator laughs, a big horsey laugh, like if Mr. Ed saw a kangaroo kick a jockey in the balls." It still makes me chuckle. When I first wrote it I laughed so hard I scared the cat. I wrote the line as an homage to Raymond Chandler, the all-time champion of similes.

Artist note by Cherise Clarke: I wanted to illustrate Leprechaun largely because, hey how often do I get a chance to draw leprechauns? Especially one placed in placed in modern times. I sort of took as an inspiration Marlon Brando in The Wild One (if he was a leprechaun). Also, like many Canadians I have an Irish streak in my heritage: my Cree great-grandmother was married to an Irishman at Fort Penetanguishene. So I am just Irish enough to exaggerate how Irish I am, and so resonate with the magical wee green folk.

The Delivery

"The Delivery" emerged whole from a dream. I didn't know what the dream meant. I only knew it came to me because it wanted to become a story. So I wrote it down as faithfully as I could. Holding the truth of a dream is a delicate undertaking.

Favorite bits: It's hard for me to say. This piece is so overwhelmingly bleak the word 'favorite' seems inappropriate. But I do appreciate the sensitivity with which the delivery person approaches the tiny charges.

Artist note by Cherise Clarke: "The Delivery" intrigued and moved me when I read it. It's interesting to me that Derrick says the story came whole out of a dream. I think it is this aspect that made me want to draw it. I was compelled by the unanswered questions in the piece. I liked the concept of the delivery person, and the discussions and revisions between Derrick and me around her image.

Shout-out to friends in Vancouver's Downtown Eastside: I used the Patricia Hotel for the 2nd illustration (no reflection on Pat's, it's a favorite watering hole and the rooms are decent—it just worked aesthetically).

ARTIST BIOS

ANTHONY CHUN

Anthony Chun is an animation director, illustrator, and papier-mâché sculptor who lives and works in Los Angeles. You can find more of his work at anthonychun.com.

CHERISE CLARKE

Cherise Clarke is a visual and performing artist currently based in small-town British Columbia, Canada, and when she can't help it, Vancouver. She dedicates her work in *Monsters* to her nieces, Colette and Leila. Even when it feels like there are monsters all around us, we can still find wild creativity and humour, great fun, and profound connection in this life.

SANDRA URE GRIFFIN

Sandra Ure Griffin has lived in the Missouri Ozarks and the Northwoods of Wisconsin. Her current home is St. Louis, where she creates digital prints from scratchboard, woodcut, sgraffito, and pen-and-ink originals. She is also a writer and an educator in the St. Louis Public Schools, where she helps urban children write and illustrate their own picture books. More of her work can be seen at www.sandrauregriffin.com.

RIINA KELLASAARE

. . . is passionate about movement & dance, color & shape, music & sound . . . and water, wind, and all that is wild . . . www.scattervision.org

ROXANNE JANE MANN

Sharing a birthday with John Lennon, born at home in Happy Valley, Texas, Roxanne started life in the wilds of the woods. Voted most creative in high school, her art has been a cornerstone of her existence all her life. She is proud to share her monster with readers of this book.

STEPHANIE MCMILLAN

Stephanie McMillan's award-winning editorial cartoons and comic strips have appeared in hundreds of venues including the *Los Angeles Times*, *Daily Beast*, the *Occupied Wall Street Journal*, the Museum of Comic and Cartoon Art (New York), the San Francisco Comic Art Museum, and numerous anthologies. She is the author of seven books, including *Capitalism Must Die!* and *The Beginning of the American Fall*. Stephanie is a lifelong organizer against capitalism.

GEOFFREY SMITH

Geoffrey Smith is a freelance artist and video game art instructor living in upstate New York. He's worked as a senior artist on a bunch of video game franchises (Guitar Hero, Skylanders, Doom, Crash Bandicoot, and a variety of Marvel games). He's painted murals in Alaska for the Alaska Raptor Rehabilitation Center and published books on Photoshop and the art of 3D imagery. Feel free to talk with him. Geoff can be reached at geoffreysmith49@gmail.com

ANITA ZOTKINA

Anita Zotkina was born in Odessa, USSR, in 1971. She was introduced to art by her parents, who were art-lovers, and who provided art supplies and encouraged her to paint at a very young age. She became a full-time artist when she was 18. Her paintings were sold at the Odessa City Garden as well as various galleries. At the age of 27 she immigrated to New England, where she continues her artistic career.

Anita doesn't focus on one subject or on one medium. Things come in waves for her, and her art expresses stages of her inner world. She never knows what she will believe tomorrow and what will be her next venture.

She gets inspired by everything: people, animals, wine, laid-back culture, music, online lectures, books and many other things.

The purpose of her art is to invoke mind-opening thoughts and feelings, to see each being as a beautiful creation of the universe that deserves love and care.

This piece started out as a simple still life, a drawing exercise, of an hourglass and a dental mold of my lower jaw set randomly on the studio floor. Something about it suggested death, and fear of dying, which seems to be the fear at the heart of everything. As I reworked the drawing for use in this book, I intended merely to add random "monster parts." In the end, it seems to have become about civilization, patriarchy, time running out, a centre that cannot cannot hold—terrifying monsters under the bed . . .

Cherise Clark

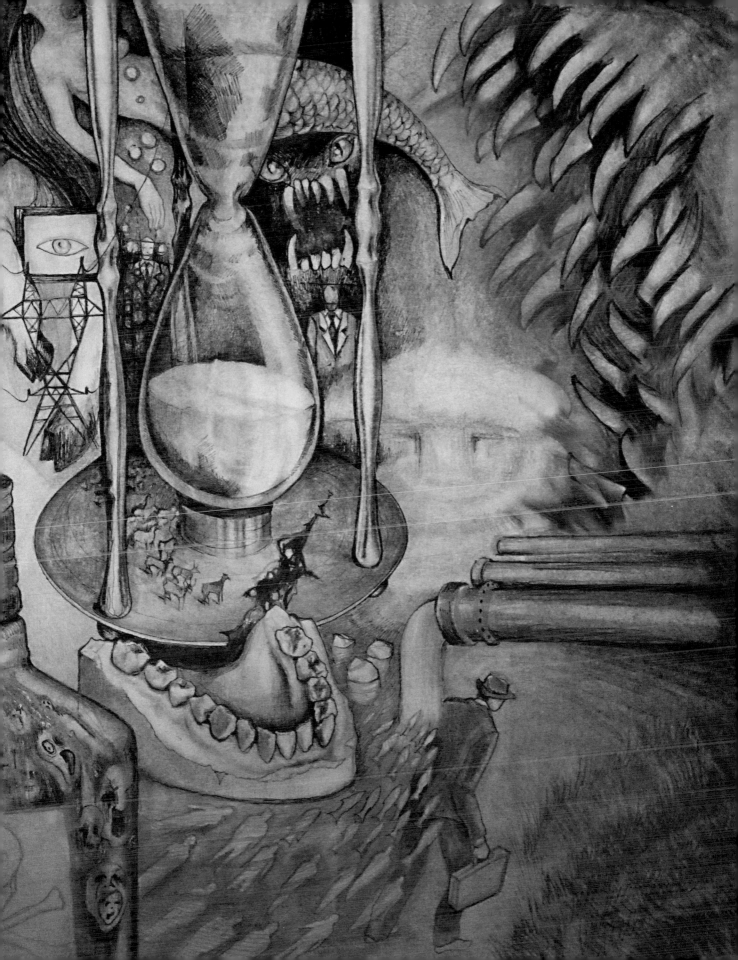

END:CIV
Resist or Die

Directed and Produced by Franklin Lopez
$20.00 • DVD • 75 minutes

END:CIV examines our culture's addiction to systematic violence and environmental exploitation, and probes the resulting epidemic of poisoned landscapes and shell-shocked nations. Based in part on Endgame, the best-selling book by Derrick Jensen, END:CIV asks: "If your homeland was invaded by aliens who cut down the forests, poisoned the water and air, and contaminated the food supply, would you resist?"

Earth at Risk
Building a Resistance Movement to Save the Planet

Edited by Derrick Jensen and Lierre Keith
$20.00 • DVD • 7 hours

The seven people in this film present an impassioned critique of the dominant culture from every angle. One by one, they build an unassailable case that we need to deprive the rich of their ability to steal from the poor and the powerful of their ability to destroy the planet. These speakers offer their ideas on what can be done to build a real resistance movement, one that includes all levels of direct action—action that can actually match the scale of the problem.

Now This War Has Two Sides

Derrick Jensen
$19.99 • CD • 115 minutes

Examining the premises of *Endgame* as well as core elements of *The Culture of Make Believe*, this lecture and discussion offers both an introduction for newcomers and additional insight for those familiar with Derrick Jensen's work. Whether exposing the ravages of industrial civilization, relaying humorous anecdotes from his life, or bravely presenting a few of the endless forms that resistance can (and must) take, Jensen leaves his audience both engaged and enraged.

How Shall I Live My Life?
On Liberating the Earth from Civilization

Derrick Jensen
$20.00 • Paperback • 304 pages

In this collection, Derrick Jensen discusses the destructive dominant culture with ten people who have devoted their lives to undermining it. Whether it is Carolyn Raffensperger and her radical approach to public health, or Thomas Berry on perceiving the sacred; be it Kathleen Dean Moore reminding us that our bodies are made of mountains, rivers, and sunlight; or Vine Deloria asserting that our dreams tell us more about the world than science ever can, the activists and philosophers interviewed in *How Shall I Live My Life?* each bravely present a few of the endless forms that resistance can and must take. Other interviewees include: George Draffan, Jesse Wolf Hardin, David Abram, Steven Wise, Jan Lundberg, and David Edwards.

Resistance Against Empire

Derrick Jensen

$20.00 • Paperback • 280 pages

A scathing indictment of U.S. domestic and foreign policy, this collection gathers incendiary insights from 10 of today's most experienced and knowledgeable activists. Whether it's Ramsey Clark describing the long history of military invasion, Alfred McCoy detailing the relationship between CIA activities and the increase in the global heroin trade, Stephen Schwartz reporting the obscene costs of nuclear armaments, or Katherine Albrecht tracing the horrors of the modern surveillance state, this investigation of global governance is sure to inform, engage, and incite readers. Other interviewees include: Robert McChesney, J.W. Smith, Juliet Schor, Christian Parenti, Kevin Bales, and Anuradha Mittal.

Truths Among Us
Conversations on Building a New Culture

Derrick Jensen

$20.00 • Paperback • 264 pages

This prescient, thought-provoking collection features ten leading writers, philosophers, teachers, and activists. Among those who share their wisdom here is acclaimed sociologist Stanley Aronowitz, who shows us that science is but one lens through which we can discover knowledge. Luis Rodriguez, poet and peacemaker, asks us to embrace gang members as people instead of stereotypes, while the brilliant Judith Herman helps us gain a deeper understanding of the psychology of abusers in whatever form they may take. Paul Stamets reveals the power of fungi, whose intelligence, like that of so many nonhumans, is often ignored. And writer Richard Drinnon reminds us that our spiritual paths need not be narrowed by the limiting mythologies of Western civilization. Other interviewees include: George Gerbner, John Keeble, Marc Ian Barasch, Martín Prechtel, and Jane Caputi.

The Vegetarian Myth
Food, Justice, and Sustainability

Lierre Keith

$20.00 • Paperback • 320 pages

We've been told that a vegetarian diet can feed the hungry, honor the animals, and save the planet. Lierre Keith believed in that diet and spent twenty years as a vegan. But in *The Vegetarian Myth*, she argues that we've been led astray—not by our longings for a just and sustainable world, but by our ignorance. The truth is that agriculture is a relentless assault against the planet, and more of the same won't save us. In service to annual grains, humans have devastated prairies and forests, driven countless species extinct, altered the climate, and destroyed the topsoil—the basis of life itself. Keith argues that if we are to save this planet, our food must be an act of profound and abiding repair: it must come from inside living communities, not be imposed across them. Part memoir, part nutritional primer, and part political manifesto, *The Vegetarian Myth* will challenge everything you thought you knew about food politics.

Songs of the Dead

Derrick Jensen

$20.00 • Paperback • 320 pages

A serial killer stalks the streets of Spokane, acting out a misogynist script from the dark heart of this culture. Across town, a writer has spent his life tracking the reasons for the sadism of modern civilization. And through the grim nights, Nika, a trafficked woman, tries to survive the grinding violence of prostitution. Their lives, and the forces propelling them, are about to collide. This is a story lush with rage and tenderness on its way to being a weapon.

Lives Less Valuable

Derrick Jensen
$18.00 • Paperback • 208 pages

At the heart of a city, a river is dying, children have cancer, and people are burning with despair. From the safe distance that wealth buys, a corporation called Vexcorp counts these lives as another expense on a balance sheet. But that distance is about to collapse.

Three

Annemarie Monahan
$16.95 • Paperback • 320 pages

As a radical feminist, Antonia has never believed in band-aid political solutions. After years of planning, she and her lover found an independent nation for women on an abandoned oil rig. Dr. Katherine North is not a sentimental woman. But after she reads that an old lover has died, she's driven to make peace with the woman who still haunts her. Growing up working-class and Catholic, Kitty Trevelyan never considered abortion when she got pregnant at eighteen. Now, at forty-one, she no longer believes that life begins at conception, but knows that hers certainly ended with it. Three very different women. All forty-one. With the same birthday. With the same birthmark. As the parallel lines of their lives converge, we realize what connects them: they were all once the same seventeen-year-old girl on an April morning, wondering whether she would be brave.

The Knitting Circle Rapist Annihilation Squad

Derrick Jensen and Stephanie McMillan
$14.95 • Paperback • 192 pages

The six women of the Knitting Circle meet every week to chat, eat cake, and make fabulous sweaters. Until the night they realize that they've all survived rape—and that not one of their assailants has suffered a single consequence. Enough is enough. The Knitting Circle becomes the Knitting Circle Rapist Annihilation Squad. They declare open season on rapists, with no licenses and no bag limits. With needles as their weapons, the revolution begins. Will the Knitting Circle triumph? Or will Officer Flint learn to knit in time to infiltrate it? Will Nick the male ally brave Daisy's Craft Barn to secure more weapons for the women? Will Marilyn put down her teenage attitude and pick up her knitting needles? Will Circle member Jasmine find true love with MAWAR's (Men Against Women Against Rape) Zebediah?

Mischief in the Forest
A Yarn Yarn

Derrick Jensen • Illustrated by Stephanie McMillan
$14.95 • Hardcover • 40 pages

Grandma Johnson lives alone in the forest and loves to knit sweaters and mittens for her grandchildren in the city. One day, when returning from a visit to the city, her solitude comes to an end when her mischievous forest neighbors reveal themselves in a delightfully colorful fashion. Who took her yarn, and what have they done with it? The colorful mystery is solved when the birds, rabbits, snakes, trees, and other dwellers of Grandma Johnson's neighborhood are seen playing with the yarn. Suddenly the forest doesn't seem so lonely, and the visiting grandkids take great delight getting to know the inhabitants of Grandma's forest. This picture book is a lesson for both young and old to connect with one's surroundings and embrace the role of good neighbors with the rest of the natural world, whether in the city or in the forest.

PM Press was founded at the end of 2007 by a small collection of folks with decades of publishing, media, and organizing experience. PM Press co-conspirators have published and distributed hundreds of books, pamphlets, CDs, and DVDs. Members of PM have founded enduring book fairs, spearheaded victorious tenant organizing campaigns, and worked closely with bookstores, academic conferences, and even rock bands to deliver political and challenging ideas to all walks of life. We're old enough to know what we're doing and young enough to know what's at stake.

We seek to create radical and stimulating fiction and non-fiction books, pamphlets, T-shirts, visual and audio materials to entertain, educate, and inspire you. We aim to distribute these through every available channel with every available technology—whether that means you are seeing anarchist classics at our book fair stalls, reading our latest vegan cookbook at the café, downloading geeky fiction e-books, or digging new music and timely videos from our website.

PM Press is always on the lookout for talented and skilled volunteers, artists, activists, and writers to work with. If you have a great idea for a project or can contribute in some way, please get in touch.

PM Press
PO Box 23912
Oakland, CA 94623
www.pmpress.org

FLASHPOINTPRESS
WWW.FLASHPOINTPRESS.COM

Flashpoint Press was founded by Derrick Jensen to ignite a resistance movement. Our planet is under serious threat from industrial civilization, with its consumption of biotic communities, production of greenhouse gases and environmental toxins, and destruction of human rights and human-scale cultures around the globe. This system will not stop voluntarily, and it cannot be reformed.

Flashpoint Press believes that the Left has severely limited its strategic thinking, by insisting on education, lifestyle change, and techno-fixes as the only viable and ethical options. None of these responses can address the scale of the emergency now facing our planet. We need both a serious resistance movement and a supporting culture of resistance that can inspire and protect frontline activists. Flashpoint embraces the necessity of all levels of action, from cultural work to militant confrontation. We also intend to win.

Flashpoint Press
PO Box 903
Crescent City, CA 95531
www.flashpointpress.com

FRIENDS OF PM PRESS

These are indisputably momentous times—the financial system is melting down globally and the Empire is stumbling. Now more than ever there is a vital need for radical ideas.

In the years since its founding—and on a mere shoestring—PM Press has risen to the formidable challenge of publishing and distributing knowledge and entertainment for the struggles ahead. With over 300 releases to date, we have published an impressive and stimulating array of literature, art, music, politics, and culture. Using every available medium, we've succeeded in connecting those hungry for ideas and information to those putting them into practice.

Friends of PM allows you to directly help impact, amplify, and revitalize the discourse and actions of radical writers, filmmakers, and artists. It provides us with a stable foundation from which we can build upon our early successes and provides a muchneeded subsidy for the materials that can't necessarily pay their own way. You can help make that happen—and receive every new title automatically delivered to your door once a month—by Joining as a Friend of PM Press. And, we'll throw in a free T-shirt when you sign up.

Here are your options:

- $30 a month Get all books and pamphlets plus 50% discount on all webstore purchases
- $40 a month Get all PM Press releases (including CDs and DVDs) plus 50% discount on all webstore purchases
- $100 a month Superstar—Everything plus PM merchandise, free downloads, and 50% discount on all webstore purchases

For those who can't afford $30 or more a month, we have Sustainer Rates at $15, $10 and $5. Sustainers get a free PM Press T-shirt and a 50% discount on all purchases from our website.

Your Visa or Mastercard will be billed once a month, until you tell us to stop. Or until our efforts succeed in bringing the revolution around. Or the financial meltdown of Capital makes plastic redundant. Whichever comes first.